Elizabeth
TAYLOR

HER LIFE IN STYLE

Elizabeth
TAYLOR

HER LIFE IN STYLE

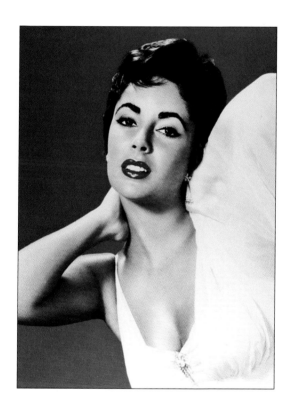

SUSAN KELLY

gettyimages

A & C BLACK • LONDON

First published in Great Britain in 2011
A&C Black
Bloomsbury Publishers PLC
36 Soho Square
London W1D 3QY
www.acblack.com

ISBN 978-1-4081-5541-7

First edition published in 2011

Typeset in 10.5 on 14pt FB Californian
Book design by Susan McIntyre
Cover design by James Watson
Proofreading: Left-Handed Productions

Printed and bound in China.

CONTENTS

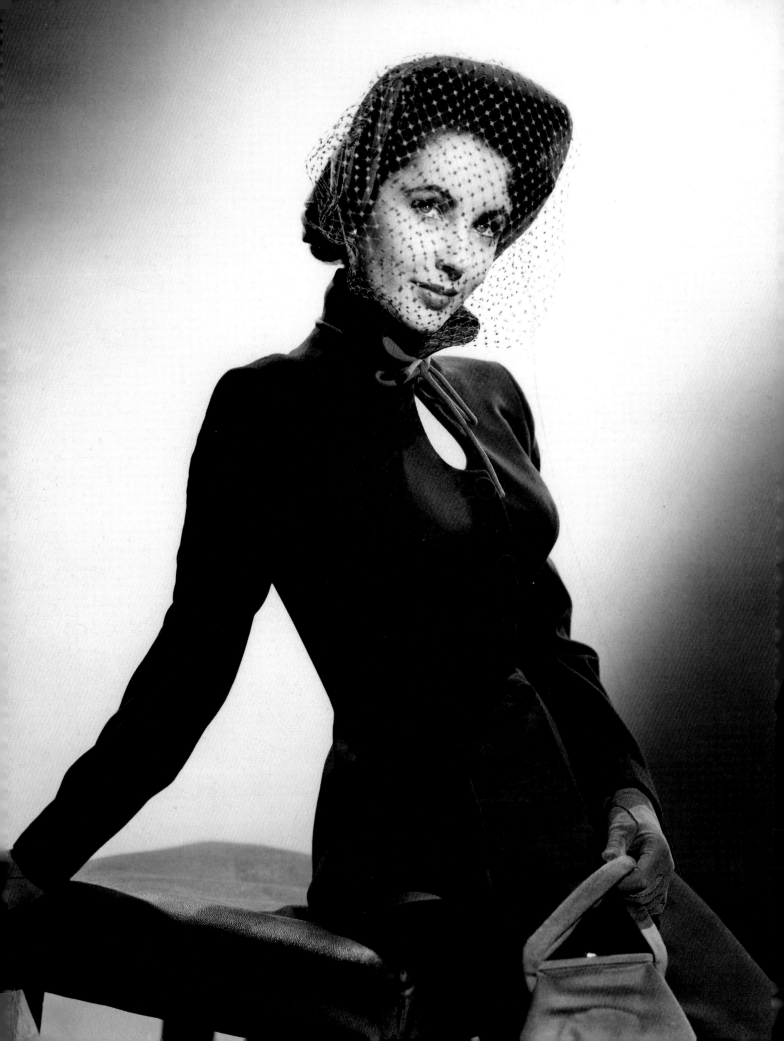

INTRODUCTION

ELIZABETH ROSAMOND TAYLOR was born on February 27, 1932 in Hampstead, London, England. She was born with a genetic 'mutation', as the doctor who delivered her described it, a rare condition called distichiasis – double rows of eyelashes framed her famous violet eyes. Seven per cent of people with lymphedema-distichiasis syndrome also suffer from congenital heart disease, which would ultimately take Elizabeth's life in March of 2011. Elizabeth's father Francis was an American art dealer, and her mother Sara (who had been an actress under the stage name Sara Sothern before her marriage) devoted herself to her daughter, ensuring Elizabeth had singing and dancing lessons, and coaching her tirelessly in the craft of acting, until the small girl could even cry on cue. As World War II drew closer, the family relocated to Los Angeles (Pasadena and then Beverly Hills) when Elizabeth was seven years old; at the age of ten, in 1943, she starred in *Lassie Come Home* for MGM studios.

Her first big hit film was the following year, 1944, when she played the lead role in *National Velvet* and became a major child star. More films followed, including *Life with Father*, and the espionage story *Conspirator*, in 1949, which saw Elizabeth playing a very adult role as the 21-year-old new bride of Major Michael Curragh (played by Robert Taylor) at the age of just 16. Although the film flopped, the young actress was applauded for her performance.

Aged just 18, in May 1950, Taylor married 23-year-old Conrad 'Nicky' Hilton in an elaborate ceremony in Beverly Hills, which was almost entirely stage-managed by MGM. Three thousand fans waited outside the church to see the couple, and Elizabeth's happiness radiated for all to see. But her ideals of the perfect romance were to elude her for the first time of many, as Nicky turned out to be a violent and abusive alcoholic with serious gambling and drug problems. Reportedly he once even kicked her in the stomach when she was pregnant, causing her to miscarry. By November of the

same year, Elizabeth cited 'extreme mental cruelty' as the reason she was filing for divorce, and their marriage ended after just 205 days.

In the early 1950s Elizabeth threw herself into work, with major roles in films such as *Father of the Bride* (1950), *A Place in the Sun* (1951) and *Beau Brummell* (1954). When Vivien Leigh could not continue with her part in *Elephant Walk* in 1954, Taylor took her place. 1956 saw her starring in *Giant* with Rock Hudson and James Dean, after which she made *Raintree County*, for which she received her first Academy Award nomination in 1958.

In 1952, on February 21, Taylor married British actor Michael Wilding. She was 19 and Wilding was 20 years her senior; they had met while making *Ivanhoe* in London. Wilding would father her two sons, Michael Howard (born in 1953 in London) and Christopher Edward (born in 1955, in Los Angeles), and Elizabeth herself believed that he brought some much-needed stability and maturity to her life. However, the marriage was not to last and the couple separated in 1956 and divorced in 1957.

Elizabeth married her third husband, Broadway and movie mogul Mike Todd, on February 2, 1957. Their daughter, Elizabeth Frances (Liza) Todd was born on August 6 of the same year. Todd adored his new bride and showered her with beautiful jewelry, including such extravangant gifts as a collection of rubies and diamonds by Cartier. Her engagement ring was a 29-and-7/8-carat diamond engagement ring; Elizabeth claimed that Mike insisted she refer to it specifically as 29-and-7/8-carat, 'because 30 would have been vulgar'. Another notable piece was an antique Belle Époque diamond necklace.

They had been married just thirteen months, and Elizabeth was only 26 years old and in the middle of filming *Cat on a Hot Tin Roof*, when she was widowed after Todd was killed in a plane crash on March 22, 1958. Allowed just one week off by the studio, the actress was compelled to finish filming. The tragedy left Elizabeth devastated, as it did Todd's best friend Eddie Fisher who was at the time married to actress

A studio portrait from Elizabeth's early career.

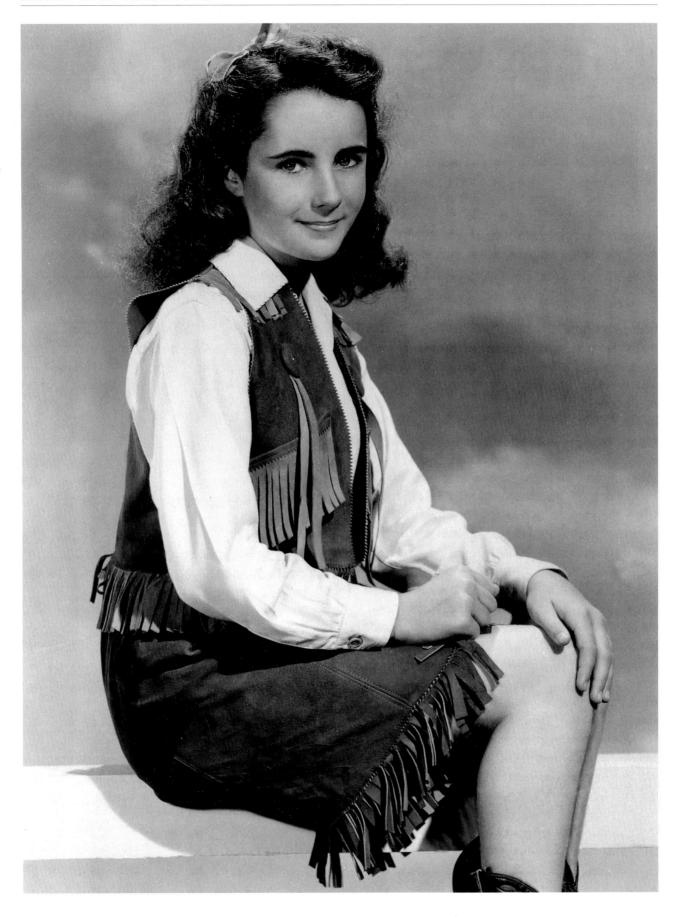

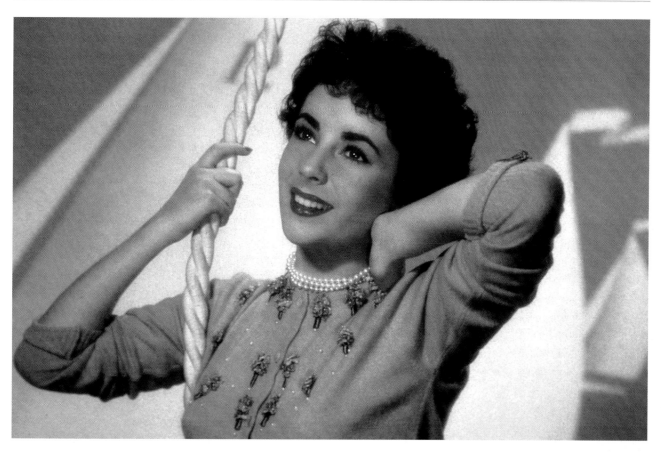

LEFT Elizabeth Taylor had her first major film success with *National Velvet*, becoming a recognised child star at the age of just 12.

ABOVE Elizabeth Taylor in 1949.

Debbie Reynolds. Eddie and Elizabeth turned to each other for comfort and consolation, and fell in love. The couple ignited a huge Hollywood scandal as Reynolds and Fisher divorced on May 12, 1959, and Eddie married Elizabeth the very same day in Las Vegas at Temple Beth Shalom. Taylor was branded a 'home-wrecker' by the press, although she defended herself, saying: 'You can't break up a happy marriage; Debbie's and Eddie's never has been'.

Taylor received her second Oscar nomination for *Cat on a Hot Tin Roof* in 1959 and her third in 1960 for *Suddenly, Last Summer*. After all these nominations, she finally won the Oscar in 1961 for her role as call-girl Gloria Wandrous in *Butterfield 8*; however, she was convinced (as were others) that this was something of a consolation prize, following Todd's death and Elizabeth's own battle with a serious bout of pneumonia.

In 1960, Elizabeth's MGM contract came to a close and she signed a deal with Twentieth Century Fox to make the film *Cleopatra*. The part was originally offered to Joan Collins. Elizabeth was not keen on the role, so she demanded the fee of $1million in an attempt to put the producers off. But the studio agreed, so she took the part and the cash; this was the first time a woman had been paid such an amount for a role. The production was famously troubled; shooting overran by a considerable amount of time, with the film ultimately taking three years to make. It also went horrendously over budget, in the end costing $37million and with its running time hitting almost four hours, and it was an absolute disaster for the studio. In the middle of the project, after $5million had already been spent, Elizabeth fell ill once again with pneumonia and filming had to be suspended. Once she recovered, the studio decided to scrap everything that had been filmed already in London, to change the director, replace some of the cast, and begin again in Italy. Richard Burton took over the role of Marc Antony, and as he and Elizabeth played out the legendary love story in front of the cameras one of Hollywood's greatest real-life romances began.

Describing the first time he saw the woman who would make him her fifth husband, Richard Burton said: 'She was so extraordinarily beautiful that I nearly laughed out loud. She... [was] famine, fire, destruction and plague... the only true begetter. She was unquestionably gorgeous. She was lavish. She was a dark, unyielding largesse. She was, in short, too bloody much... Those huge violet blue eyes... had an odd glint... Aeons passed, civilizations came and went while these cosmic headlights examined my flawed personality.'

Both married to other people, their flamboyant affair sparked enormous public indignation and outrage, as well as an official condemnation from the Vatican accusing them of 'erotic vagrancy'. It was another very public scandal for Elizabeth; she and Fisher announced their divorce in 1962 and finalized it in March 1964. Nine days after the divorce was finally granted, Elizabeth married Richard on March 15, 1964, in Montreal, proclaiming 'this marriage will last forever'.

The pair earned a reputation as Hollywood's most famous, glamorous, outrageous and volatile couple, and the romance of their relationship captured public imagination. Elizabeth and Richard starred opposite each other in *Who's Afraid of Virginia Woolf?* (for which Elizabeth won an Oscar in 1967) and Franco Zeffirelli's production of *The Taming of the Shrew*, as well as working together on the film adaptation of Dylan Thomas's *Under Milk Wood*. Their marriage was passionate, but also tempestuous; Burton explained, 'Elizabeth and I lived on the edge of an exciting volcano. I'm not easy to be married to or live with. I exploded violently about twice a year with Elizabeth. She would also explode. It was marvellous. But it could be murder.'

Burton indulged Taylor's love of jewels, famously showering her with some of the world's most historically-important and beautiful pieces throughout their relationship. The first diamond he bought her was the 33.19-carat Asscher-cut Krupp Diamond, which Elizabeth wore in a ring and can be seen in a number of her films made after 1968 as well as during her appearance on Larry King Live (CNN, 2003). In 1969, for her 37th birthday, Burton spent $37,000 to acquire the La Peregrina Pearl for his wife. The history of the pearl fascinated them both; it had been owned by Mary Queen of Scots, who was given it during her engagement to Phillip II of Spain in 1554, as well as by the Spanish queens Margarita and Isabel who both wear it in 16th-century portraits by Velasquez. The Bonapartes also owned the pearl, in the early 1800s. Elizabeth wore it in the films *A Little Night Music* and *Divorce His – Divorce Hers*, as well as in 1969 studio photographs to publicize *Anne of the Thousand Days*.

In 1972, Burton presented Elizabeth with the exquisite heart-shaped Taj-Mahal Diamond for her 40th birthday. A yellow-gold rope-patterned necklace set with diamonds and rubies replaced the original silk chord, and the large, flat stone is inscribed with the words 'Love is Everlasting' in Parsee. Burton was very pleased with the piece, remarking: 'This diamond has so many carats, it's almost a turnip.'

The most famous purchase Richard made for Elizabeth was a pear-shaped 69.42-carat diamond, which would be known as the Burton-Taylor Diamond. Taylor first wore it in public for the 40th birthday party of Princess Grace of Monaco, for which it was flown from New York accompanied by two armed guards. When she put the diamond up for sale, in 1978, it won a price of $5 million at auction.

Elizabeth went on to acquire one of the greatest private collections of jewelry in the world, including pieces by Boucheron, Bulgari, Cartier, Chopard, Gerard, JAR, Ruser, Schlumberger, Tiffany, Van Cleef & Arpels, and David Webb. She was well aware of her good fortune, but always said that she only ever saw herself as someone who was looking after the pieces in her collection rather than its 'owner': 'I believe that I am their custodian, here to enjoy them, to give them the best treatment in the world, to watch after their safety, and to love them'. Elizabeth was well aware that jewelry is only ever a 'temporary gift', saying: 'Nobody ever owns anything this beautiful. We are only the guardians.'

Her relationship with Richard Burton marked a new stage in Elizabeth Taylor's career, as they appeared together in a large number of productions, but none achieved critical acclaim except for *Who's Afraid of Virginia Woolf?* Many were still box-office successes though, as the public desire to see the couple together seemed inexhaustible. Taylor made other films with different leading men and excellent directors, but all were commercial failures. It seemed her career had reached a plateau; she was still a star, but only with Burton.

Enjoying tea and cake, a fresh-faced young Elizabeth Taylor looks innocently radiant in her pink dressing room.

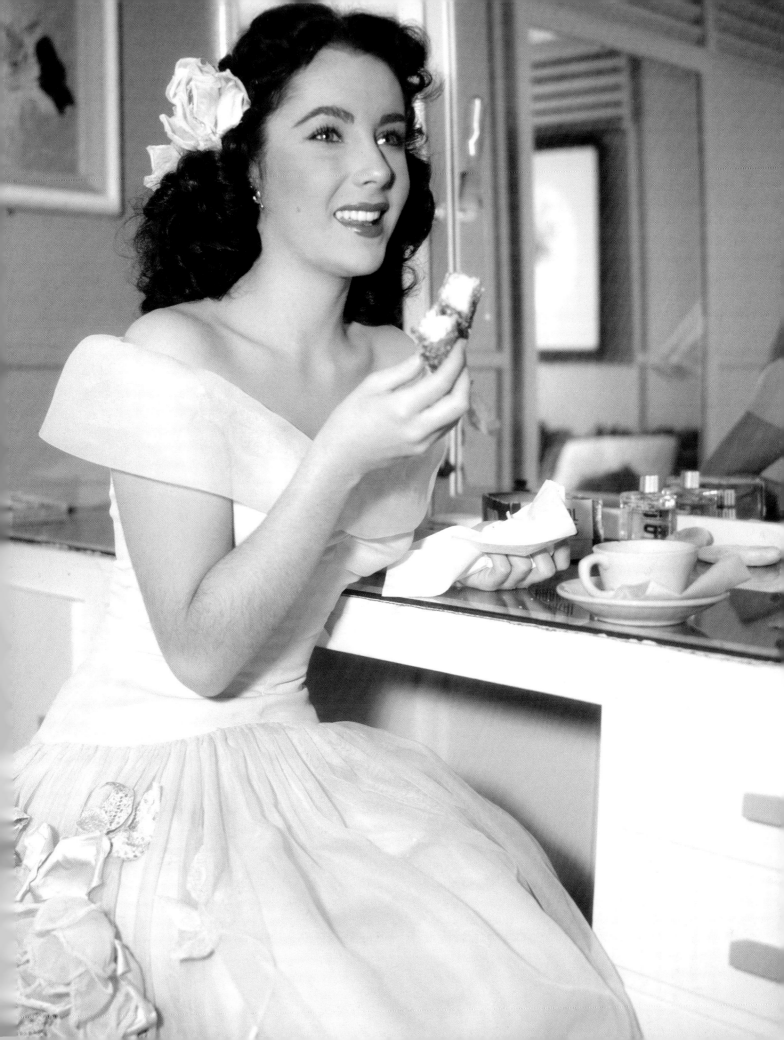

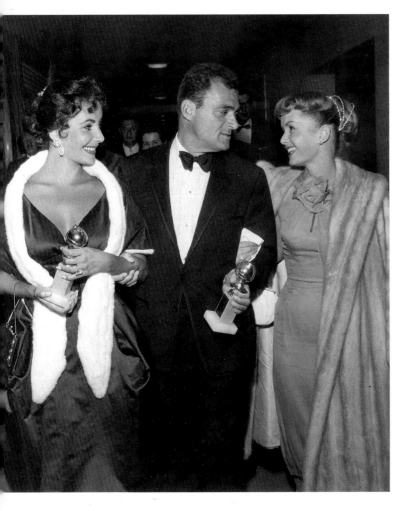

OPPOSITE:

TOP LEFT Elizabeth Taylor married Conrad 'Nicky' HIlton in 1950, aged just 18.

TOP RIGHT With third husband, Mike Todd on April 5, 1957 at their home.

BOTTOM LEFT With Eddie Fisher and sons.

BOTTOM RIGHT While filming *Goforth*, later entitled *Boom*, in 1967 Richard Burton and Elizabeth Taylor relax on their yacht 'Kalizma' off the coast of Capo Cacci in Sardinia.

The marriage was a passionate one, but fuelled by drinking and fraught with fierce arguments about Burton's alcoholism and infidelities. Elizabeth finally left him, but her announcement of their separation shocked him; he wrote to her repeatedly, declaring his love and devotion to her.

'I love you, lovely woman. If anybody hurts you, just send me a line saying something like "Need" or "Necessary" or just the one magic word "Elizabeth", and I will be there somewhat faster than sound.'

'You must know, of course, how much I love you. You must know, of course, how badly I treat you. But the fundamental and most vicious, swinish, murderous and unchangeable fact is that we totally misunderstand each other. You are as distant as Venus - planet, I mean - and I am tone deaf to the music of the spheres. I love you and I always will. Come back to me as soon as you can.'

Burton's remorse tormented him ceaselessly, but Elizabeth did not reply to his letters and in 1974 they divorced in a Swiss court. Elizabeth stated that 'life with Richard had become intolerable'. However, despite each entering into new relationships, when they met again in the summer of 1975 to discuss their settlement they realized that they loved each other still. Both healthier, happier, and seeming stronger, they remarried again on October 10, 1975 in Botswana. But although Burton had been through a detox program for his problems with alcohol, Elizabeth was still drinking; within weeks of their second marriage, Richard would begin drinking again as well. Not much time passed before they had returned to their alcohol-fuelled rage-and-make-up sessions, and by January 1976 they were sleeping in separate bedrooms. After just five months of their second marriage, Burton left Taylor, furious and humiliated, for another woman. Their second and final divorce was granted in July 1976.

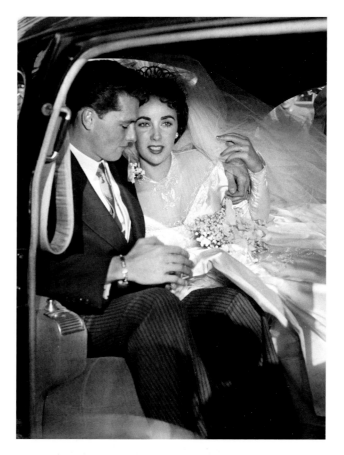

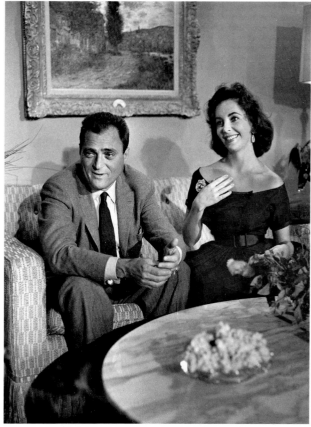

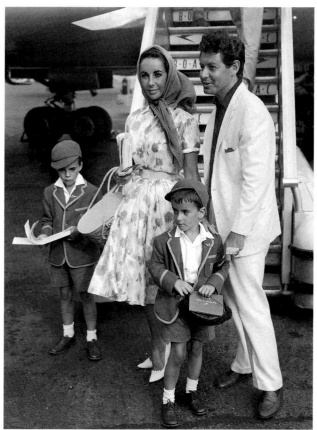

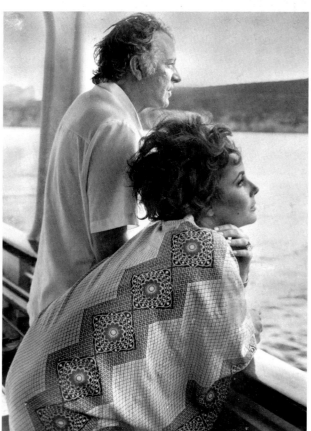

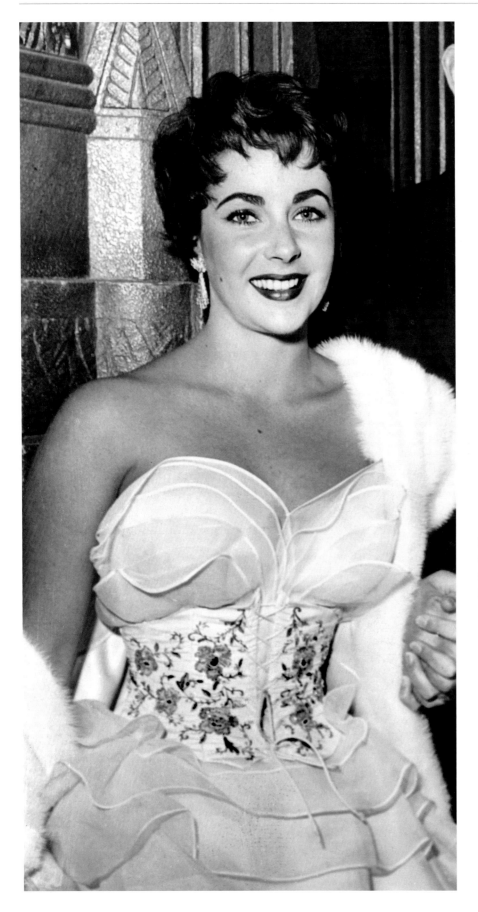

Never one to shy away from a
dramatic look, Taylor in one of her
extraordinary evening gowns, tightly
laced to accentuate her tiny waist.

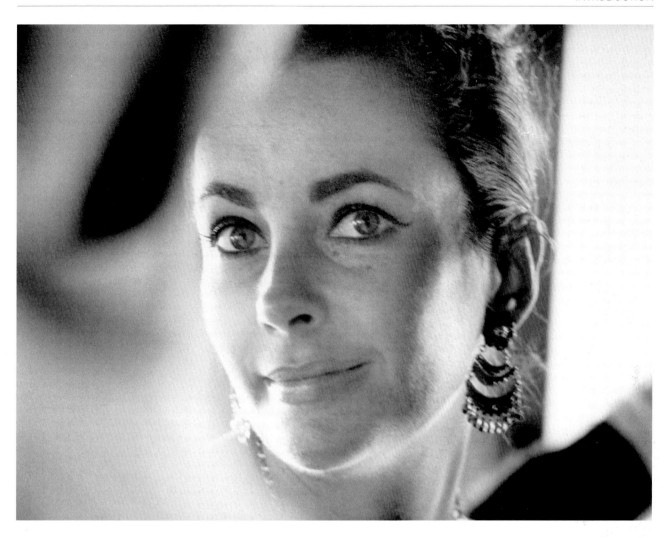

Sun-drenched glamour on set in Italy.

The next man to sweep Elizabeth Taylor off her feet was 50-year-old John Warner, a former US naval secretary from Virginia who became Republican Senator. After the tumult of her love for Richard Burton, Warner seemed a safe pair of hands, with his Southern charm and important public role. They married in 1976, Elizabeth's seventh marriage, and for a time Elizabeth found politics and the role of Senator's wife fascinating. Her public profile made her an enormous asset in terms of publicity and fundraising, and she played the role perfectly for a time – perhaps imagining herself as a Jackie-Kennedy-type figure. But Warner was a workaholic and Taylor had to admit that the life of a Washington Widow was not for her. Eventually the campaigning and the loneliness became too much for her, her weight ballooning in a physical manifestation of her dissatisfaction. The marriage ended in 1982.

Elizabeth was reunited with Richard Burton, professionally at least, for a revival of Noel Coward's *Private Lives*, which toured the USA the following year. She received poor reviews for her performance and the play ran for only 63 performances. Finally realizing she had to confront some of her demons, a depressed Taylor checked into the Betty Ford Clinic to deal with her addictions to alcohol and prescription painkillers.

In 1984, aged 58, Richard Burton died suddenly from a massive brain haemorrhage. His family refused to invite Elizabeth to the funeral, fearing the media frenzy that would accompany her. Days after his death, a letter from Richard arrived at Elizabeth's home. Written just a few days before he died, in the letter Burton declared that he had been happiest with her, that he wanted to 'come home' to her, and asked whether there could be another chance for them to be together. Elizabeth kept this last

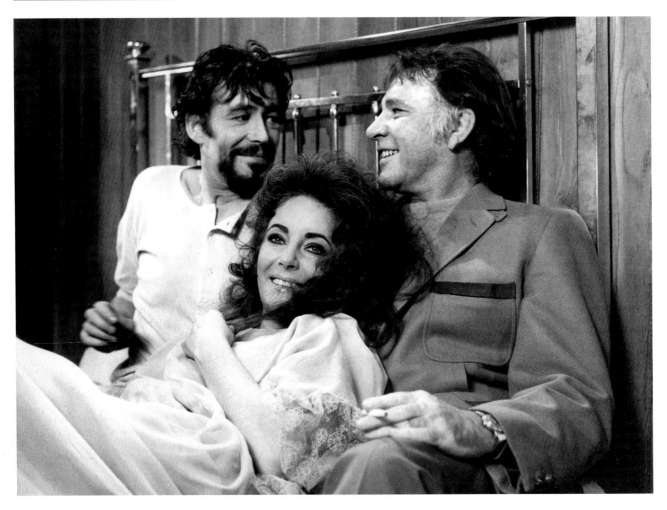

On the set of the adaptation of Dylan Thomas' *Under Milk Wood*, a play originally written for radio. With Peter O'Toole and Richard Burton. Elizabeth played the part of Rosie Probert.

love letter close for 27 years, and, in accordance with her dying wish, it was buried with her.

In 1985, Elizabeth's old friend and ex-co-star Rock Hudson was diagnosed with AIDS and it was announced that he was dying. Elizabeth had already taken an interest in charities raising money for the fight against AIDS, but the tragedy of losing her friend spurred her on to even greater efforts to raise awareness and funds to research the disease. At a time when there was still an enormous amount of fear, bigotry and prejudice about AIDS, Taylor made it her mission to support and promote AIDS fundraising. Understanding both how the media works, and also the power of celebrity, she used her influence and public profile to promote interest in and support for the cause. In September 1985 she became Founding National Chairman of amfAR (The American Foundation for AIDS Research) and established The

Elizabeth Taylor HIV/AIDS Foundation in 1991. It was estimated that her appearance at a fundraiser would bring in ten times more money than one without her.

By the late 1980s, Taylor was again struggling to control her use of prescription drugs to deal with the constant pain from old injuries and illnesses. The height of her addiction saw her consulting with three different doctors at the same time, none knowing about each other and each prescribing her strong medication. In December of 1988 she entered the Betty Ford Clinic a second time. When she emerged, it was with a new friend – Larry Fortensky, a construction worker and carpenter from Southern California. Despite the unlikely nature of the match they became a couple, based in no small part on their mutual commitment to sobriety and in October 1989 Larry moved into Elizabeth's Bel Air estate. In 1991, the pair married at Neverland Ranch in a ceremony

hosted by Elizabeth's close friend Michael Jackson.

Media interest was enormous – some guests couldn't hear anything of the ceremony because of the swarm of helicopters overhead – and Elizabeth sold photographs of the event to magazines and newspapers around the world to raise money for her Elizabeth Taylor AIDS Foundation. But Fortenksy was never really comfortable in the showbiz world, whereas Elizabeth had never known any other kind of life. By 1996 Taylor had filed for divorce, and her eighth marriage was over.

Taylor showed herself for the survivor she was, enduring brain surgery in February of 1997 to remove a tumour, which was pronounced benign following the operation. She emerged into the public eye just six days later. She continued her fundraising work, and by the turn of the century had raised $120million for the fight against AIDS. In 2000, the queen of Hollywood's royalty was honoured in the UK with the title of Dame Commander of the Order of the British Empire, and in 2001 she received the Presidential Citizens Award for her humanitarian work.

Having suffered another bout of pneumonia, in 2000, Elizabeth went straight back to work, this time starring in the 56th film of her career *These Old Broads*. Her co-stars were Shirley MacLaine, Joan Collins, and her former romantic rival Debbie Reynolds.

Taylor's health continued to deteriorate, and in 2004 she developed scoliosis and congestive heart failure, leaving her dependent on a wheelchair. In February of 2011, Taylor was admitted to Cedars-Sinai Medical Centre in LA, as further symptoms of congestive heart failure developed. On March 23 2011 she died, aged 79 and surrounded by her four children. Buried in a private Jewish ceremony at Forest Lawn Memorial Park in California, her funeral was delayed by 15 minutes at her request, so that 'she could even be late to her own funeral'.

Adored by millions around the world, Elizabeth Taylor's talent, intelligence, charm, wit, tremendous sense of fun and passion for life were legendary, as of course was her beauty. In the words of director Austin Pendleton: 'There was something about her beauty that included you rather than excluding you, which isn't always the case with extraordinarily beautiful people.' She was an inspirational figure, surviving personal loss and heartbreak, severe health problems and significant physical pain. Throughout it all, her iconic celebrity

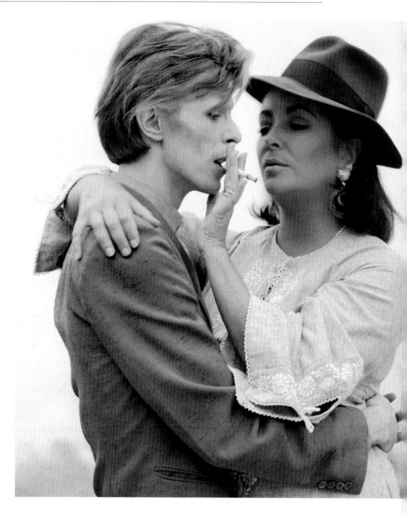

Sharing a cigarette with David Bowie; this was the first time the two met

status never waned and for decades her face adorned countless magazine covers around the world. As her son Michael Wilding put it, she was 'a tremendous woman who lived life to the fullest, with great passion, humour and love.'

Idolized as a goddess of the silver screen, her very public private life was both turbulent and thrilling. Married eight times, to seven different husbands, no one would deny that Elizabeth Taylor adored romance and longed for love, a soulmate, a home and children. She knew that companionship, respect and affection must not be taken for granted and, rather than valuing marriage too lightly, in fact went further than most in search of true love. She converted to Judaism for her marriages to Fisher and Todd, and of course married Richard Burton twice.

When Elizabeth was asked why she married eight

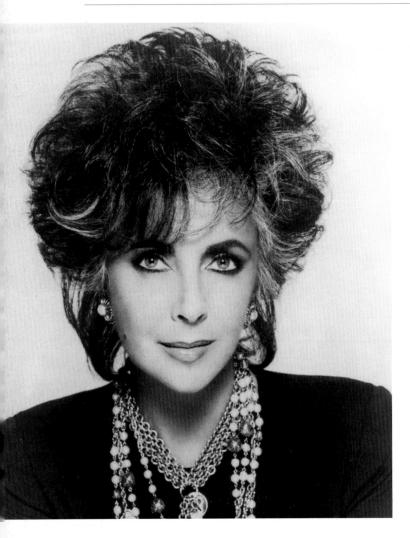

times to seven different men, she replied, 'I don't know, honey. It sure beats the hell out of me.' Launched into the world of Hollywood-style romance when she was a young teenager, Taylor herself admitted it was an odd way to learn about the emotions and feelings of a grown-up. 'I suppose I learned about love the wrong way,' she said in April of 1952. Attempting to explain the failure of her marriages to Richard Burton, Taylor poignantly declared, 'Perhaps we loved each other too much.'

Taylor's overwhelming commitment to the people she loved and her urge to protect and nurture meant that her life and legacy was much more than just her performances on stage and screen; a movie-star since the age of twelve, Elizabeth had lived almost her whole life in the spotlight and was one of Hollywood's last great stars. Easily one of the most-photographed celebrities in the world, she appeared on countless magazine covers (including *Esquire*, *Life*, *TV Movie Screen*,

Cosmopolitan and *Vanity Fair*) throughout her life.

Her acting career was packed with memorable roles, spanning 1942-2001, from *There's One Born Every Minute* to *These Old Broads*. Her filmography is testament to her versatility as an actress, as are her two Academy Awards (for *Butterfeld 8* and *Who's Afraid of Virginia Woolf?*) and the further three for which she was nominated as Best Actress. She was Velvet Brown, Cleopatra, Rosie Probert, Maggie the Cat and Katharina, but above and beyond everything she was Elizabeth Taylor.

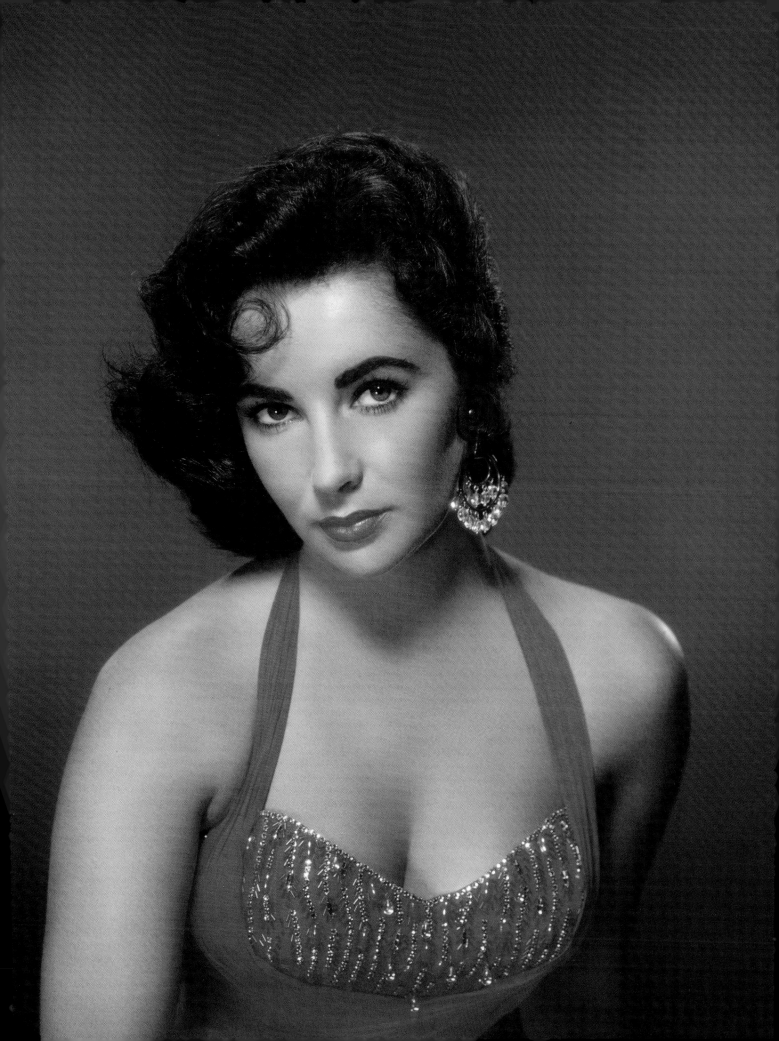

GALLERY

On the set of *Conspirator*, 1948, directed by Victor Saville. Aged just 16, Taylor leapt into a very adult role, the 21-year-old bride of a British Army officer.

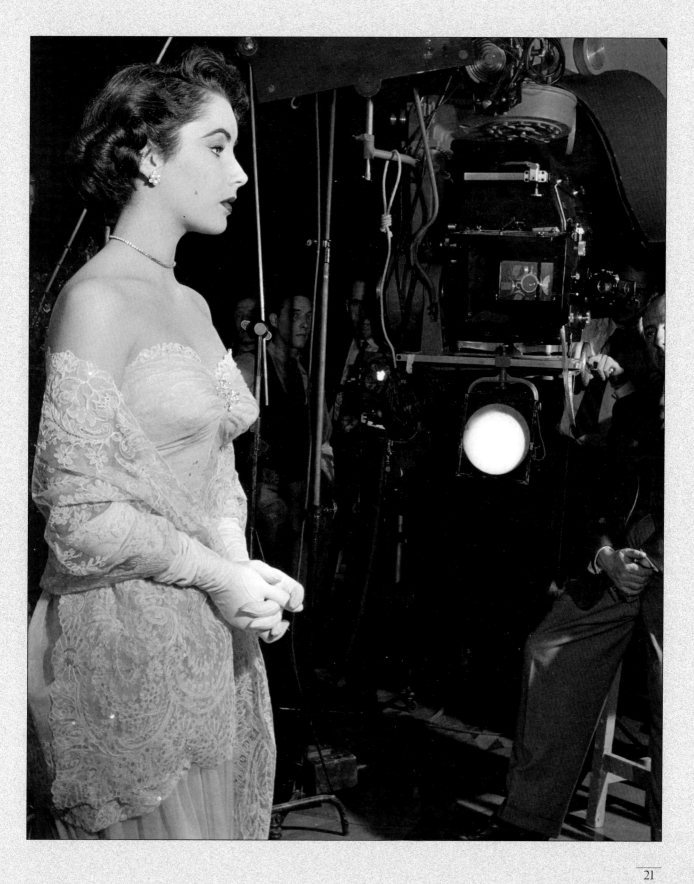

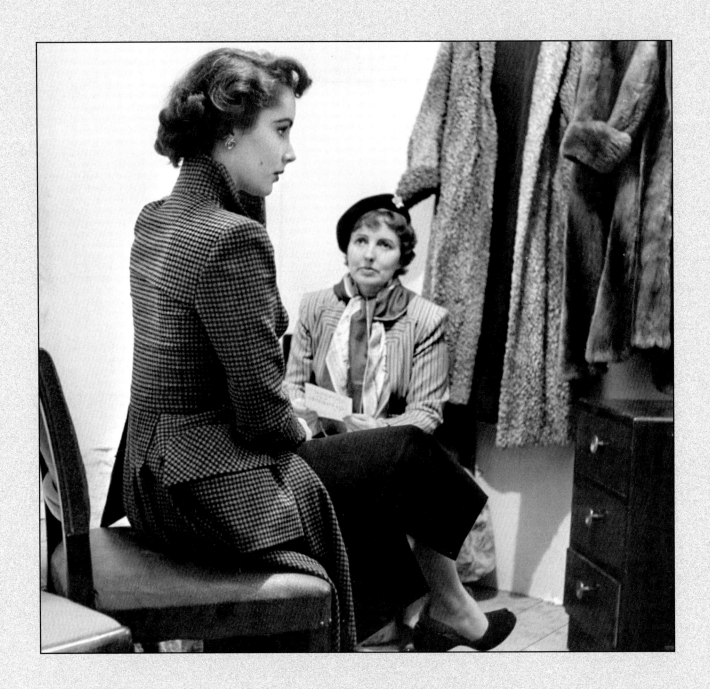

Elizabeth, looking focussed and determined, on a shopping trip with
her mother in 1948.

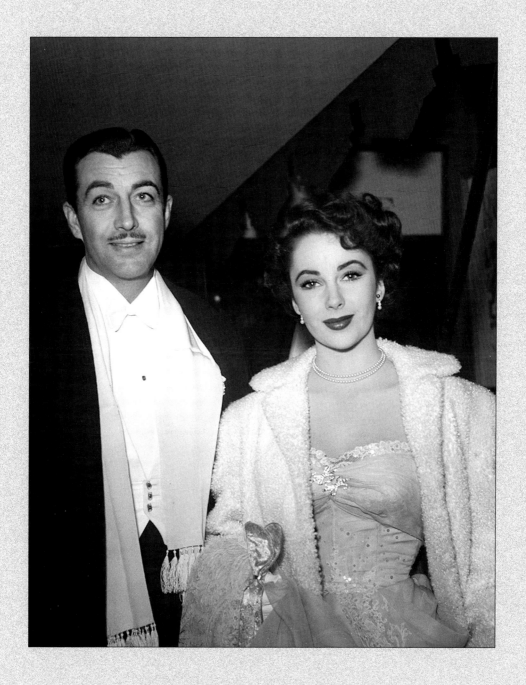

Robert Taylor, her *Conspirator* co-star, with Elizabeth on December 7, 1948 at the Royal Command Film Show.

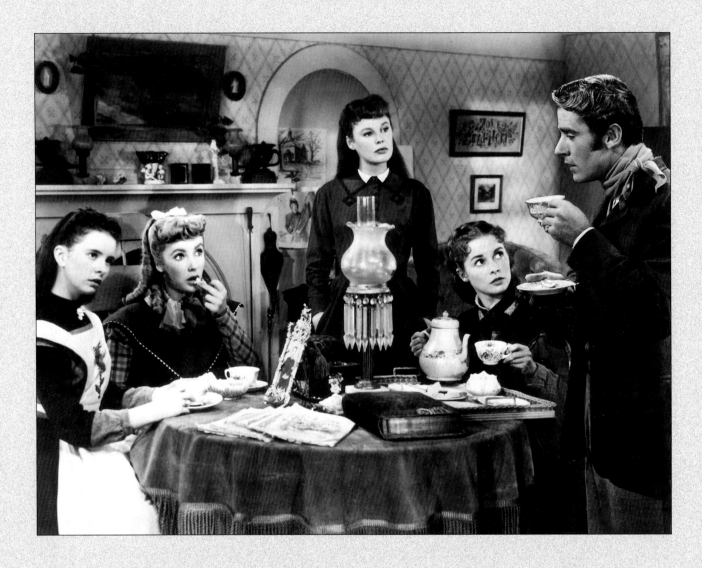

On the set of the 1949 film, *Little Women*. From left to right, actors
Margaret O'Brien, Elizabeth Taylor, June Allyson, Janet Leigh, and
Peter Lawford sit around a table having tea.

RIGHT An early publicity photograph showing the young star
enjoying some creative relaxation time.

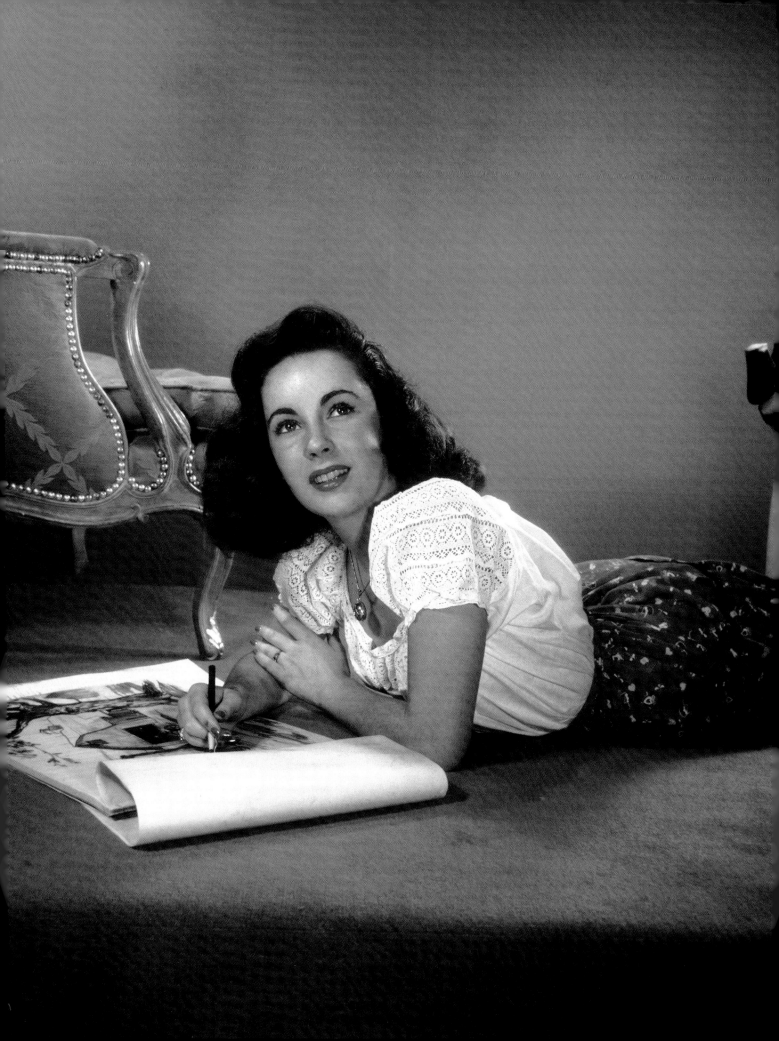

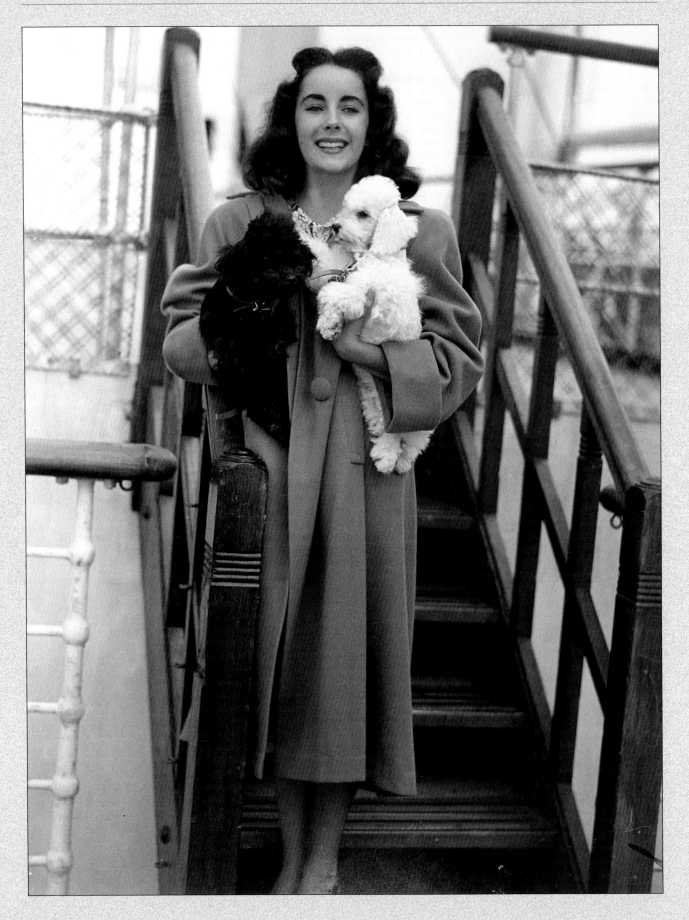

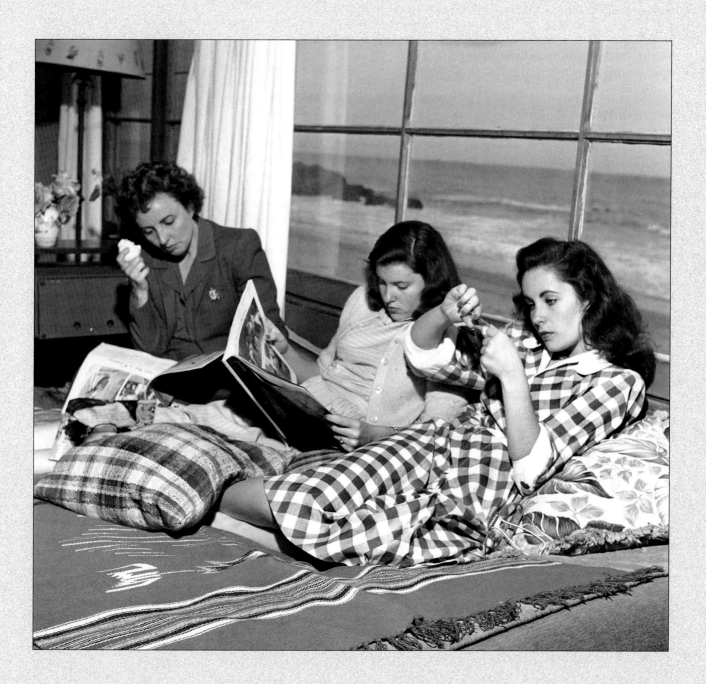

Photo of a young Elizabeth around 1949. Her mother, Sara, is on the far left.

LEFT Pictured with her two French poodles, about to board the liner *Queen Mary* on September 4, 1947, Taylor returns to America after a short stay in London.

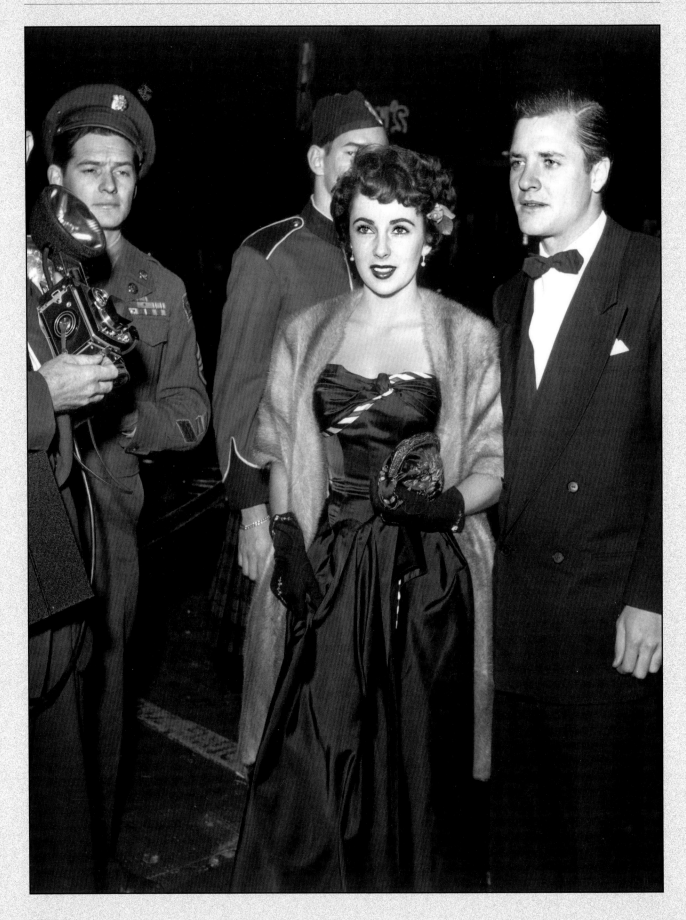

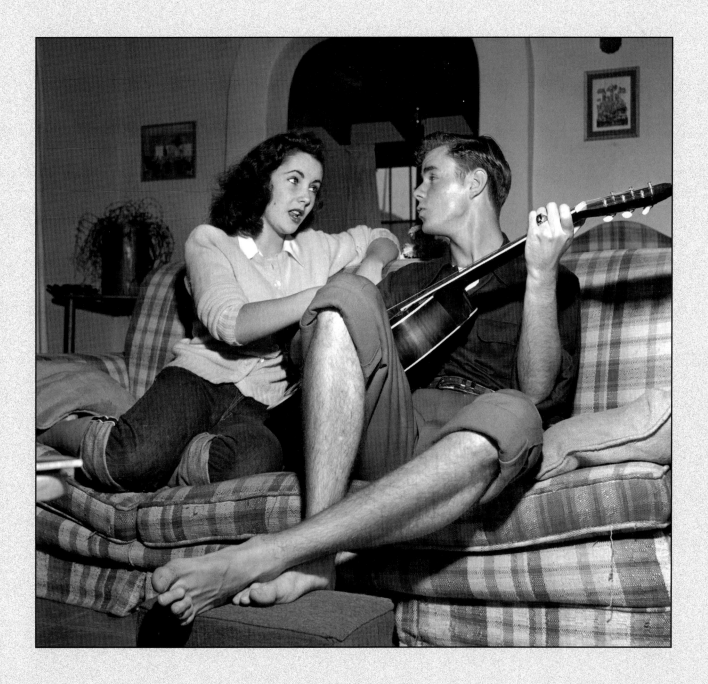

With Conrad 'Nicky' Hilton in 1949.

LEFT Arriving at a film premier in LA c.1948 Elizabeth Taylor wears an elegant evening gown with a fur coat. American actor Richard Long accompanies her.

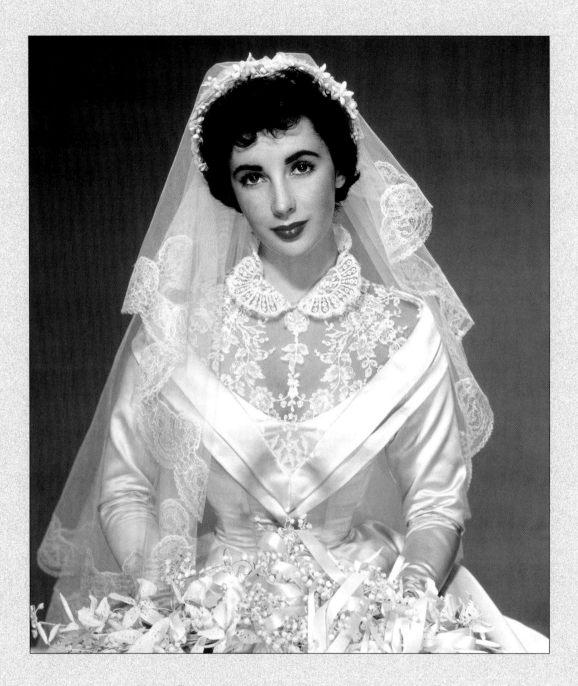

Elizabeth Taylor wearing a wedding dress with a plunging neckline
and demure chiffon overlay, for her role in the 1950 MGM film
Father of the Bride. She starred with Spencer Tracy.

RIGHT A portrait of Elizabeth Taylor in the 1950s.

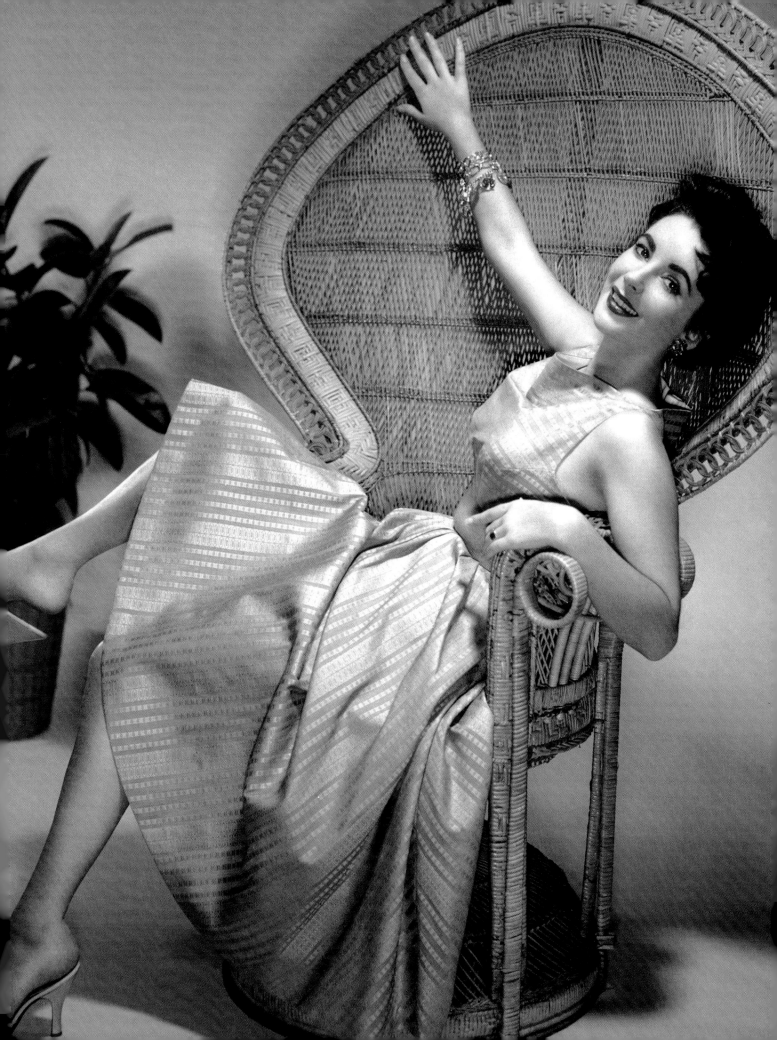

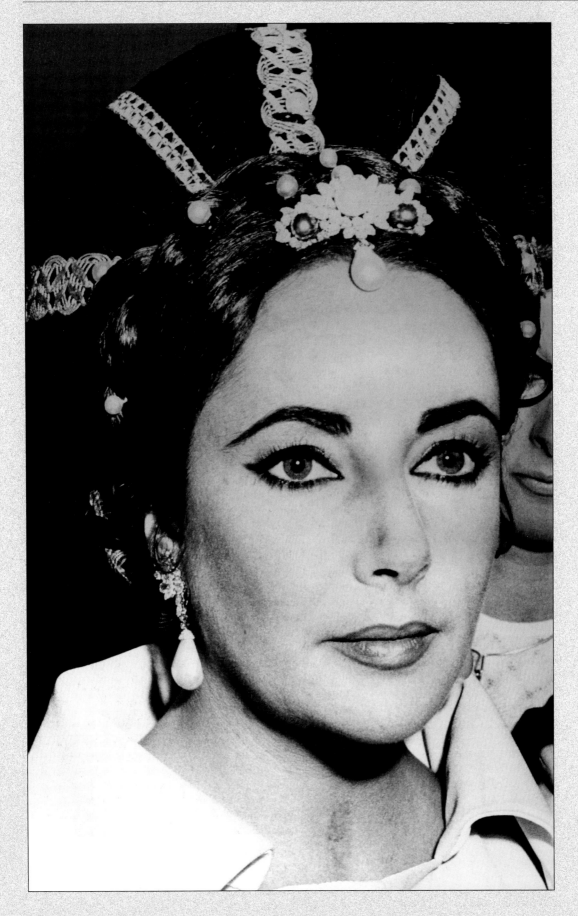

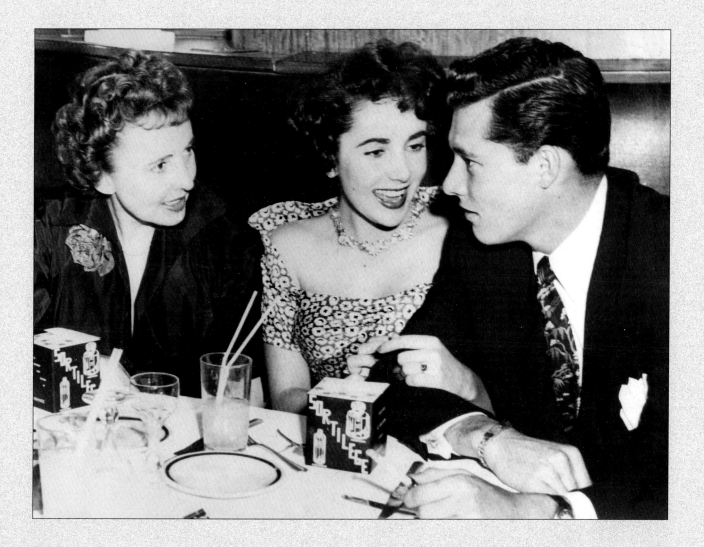

Taylor at the Stork Club in New York City on March 16, 1950, with her mother Sara and fiancé Conrad Hilton, son of the wealthy hotel magnate.

LEFT Taylor in regal headdress with antique pearl ear-drops, her hair adorned with pearls and gemstones, and her trademark eyeliner and perfectly-groomed arched brows. Her collection of jewels was world famous and historically significant, and she continued adding to it throughout her life.

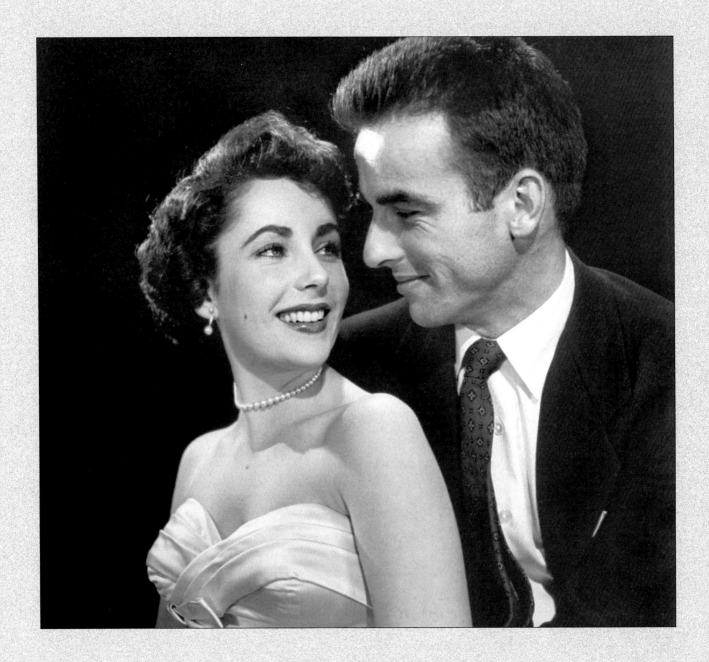

Friends Elizabeth Taylor in structured, strapless gown and
Montgomery Clift photographed together during time of filming A
Place in the Sun.

RIGHT Grace Kelly, left, Elizabeth Taylor and Lorraine Day arrive
in Los Angeles, before Kelly gave her film career up to become
Princess Grace of Monaco

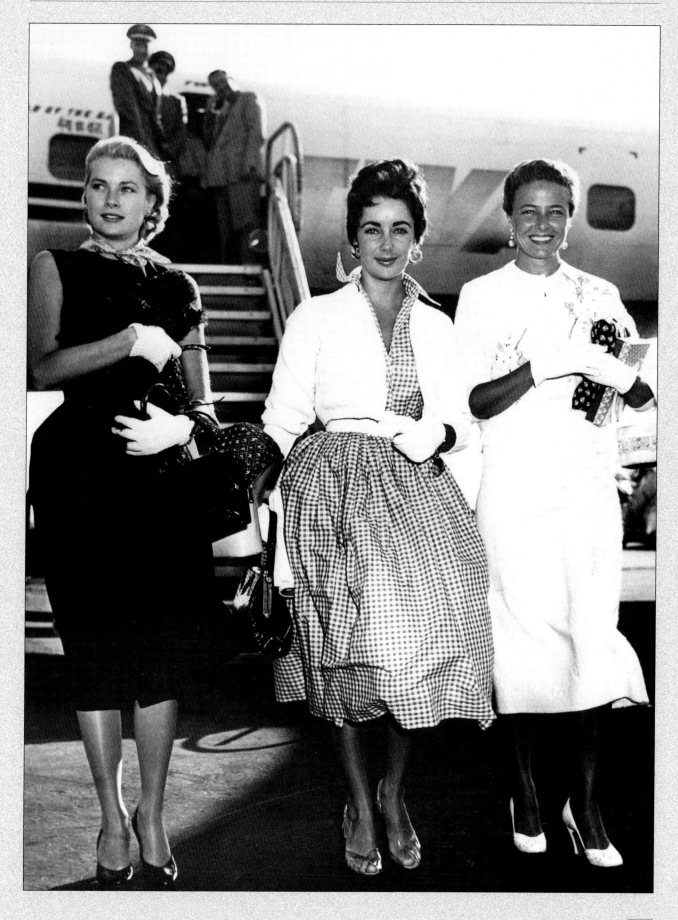

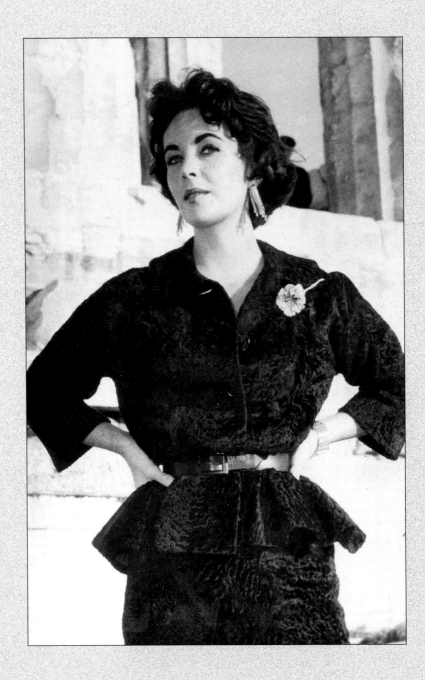

Taylor tailored to perfection, the epitome of 1950s chic. With her boxy, big-buttoned suit jacket tightly belted in her trademark fashion, Taylor's bracelet, brooch and earrings add further distinctive touches as she poses on the steps of the Acropolis in Athens.

RIGHT Taylor poses for a portrait wearing an off-the-shoulder, loose-sleeved gown in a seductively sheer fabric.

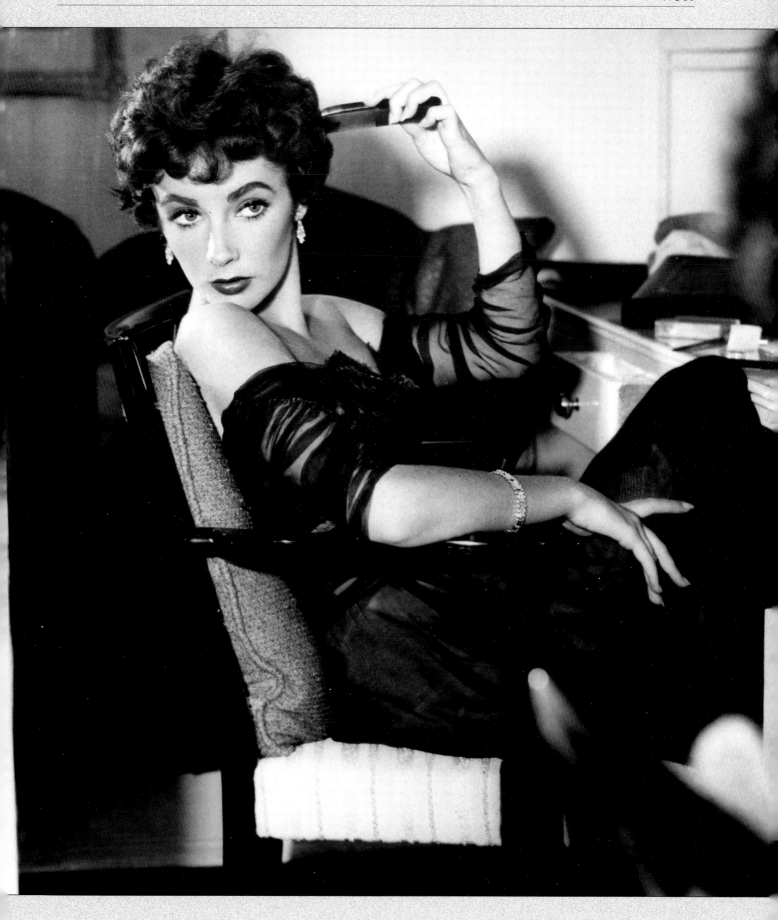

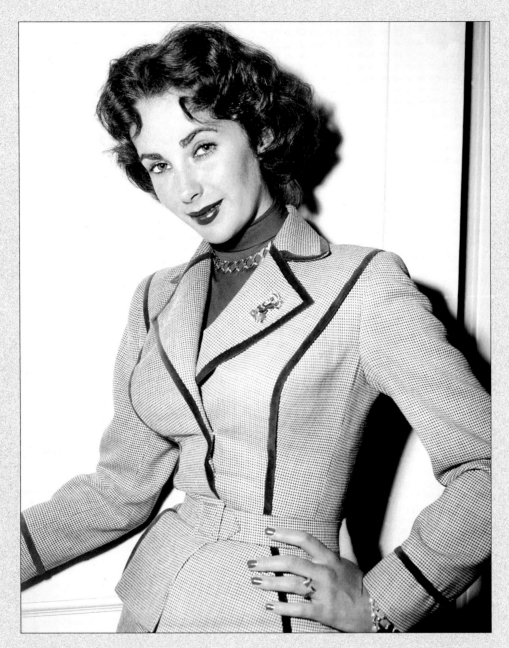

On her 19th birthday, 1951, wearing a belted, fitted contrast-trim
suit at the Waldorf Towers in New York.

RIGHT Taylor smoulders languidly in another 1950s portrait, her
outfit combining cream silk, satin and lace with exquisite detailing in
its covered buttons and delicately pleated collar.

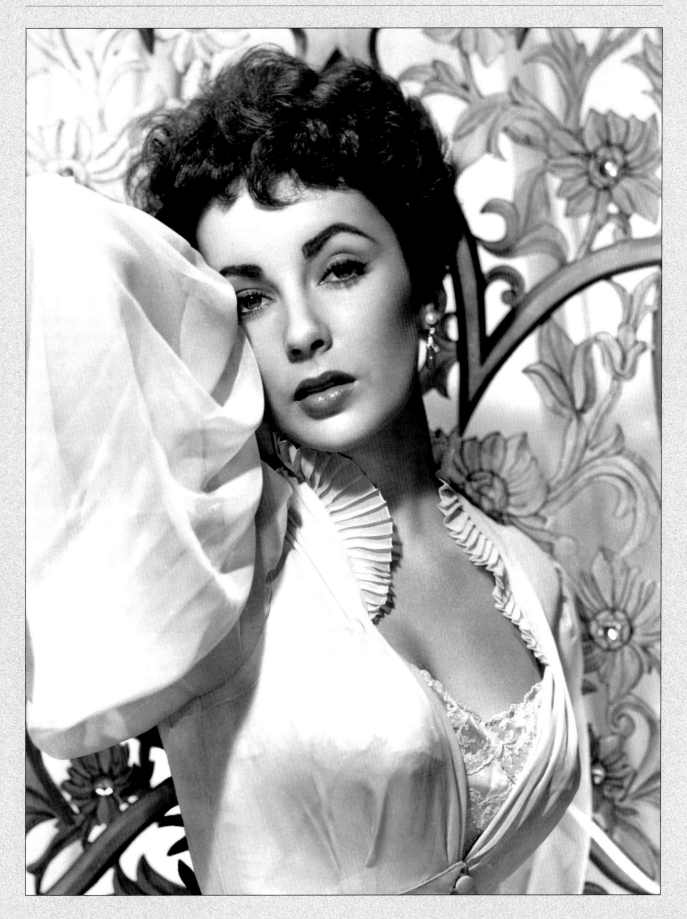

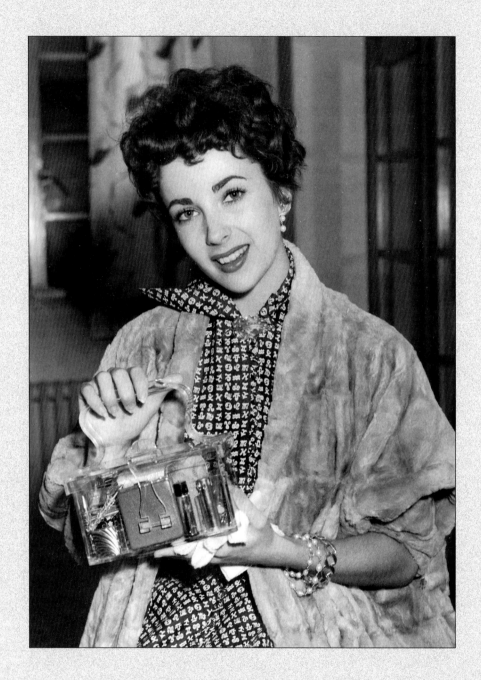

In a fresh printed dress and fur cape, holding her gloves, Elizabeth
clutches a transparent plastic handbag, at the Savoy Hotel in
London, June 20, 1951.

RIGHT Cool and collected in a full-skirted printed cotton dress in
the heat of a summer portrait session.

LEFT Looking radiantly happy, Taylor displays her engagement ring at LaGuardia Field, where she stopped off on her way to London. Aged almost 20, she was off to wed British actor Michael Wilding, who was 41. Her ring was a huge sapphire encircled with two rows of diamonds.

RIGHT Following her wedding to Michael Wilding on February 21 1952.

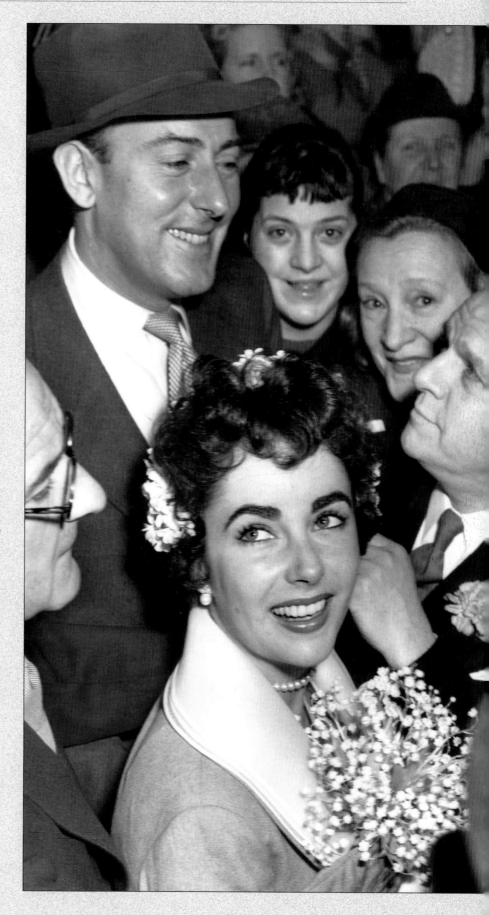

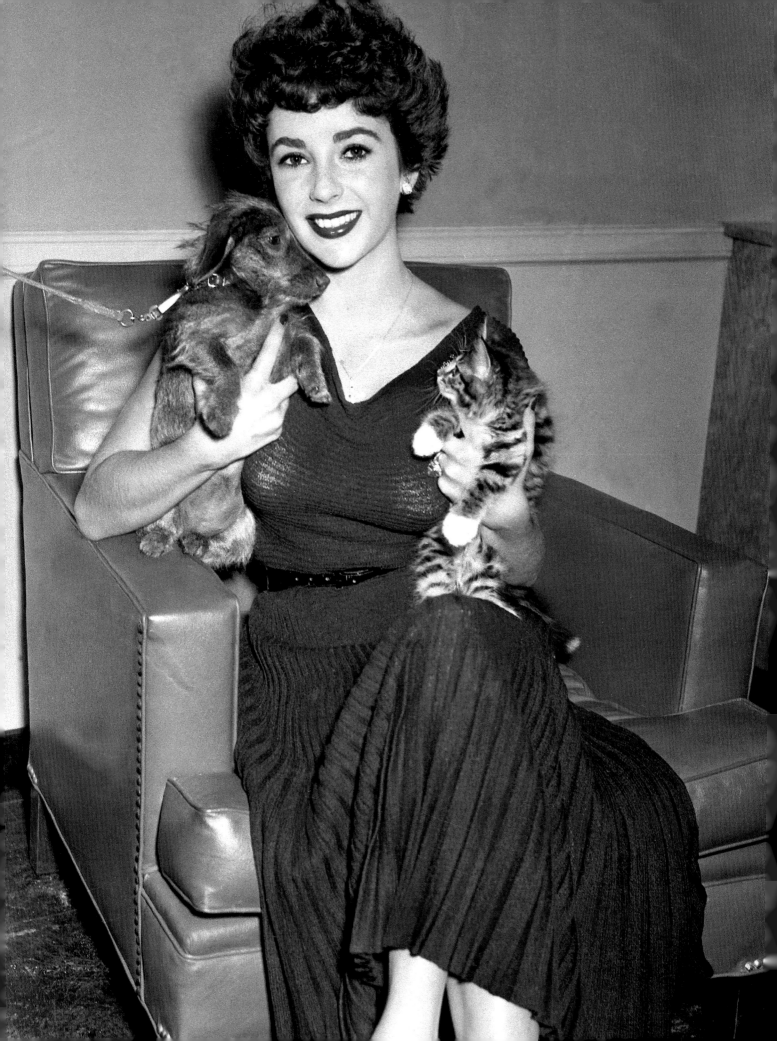

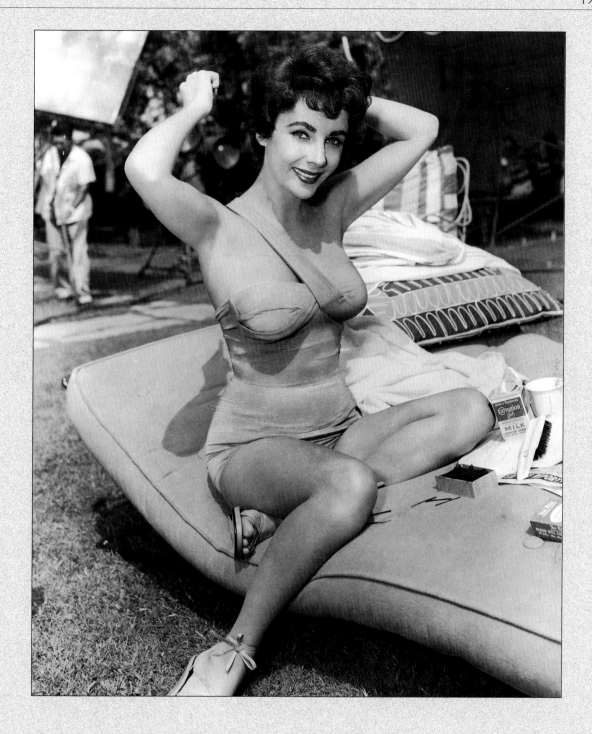

She's got it all: on the set of *The Girl Who Had Everything* in 1953, Elizabeth fixes her hair while she sits on a sun-lounger wearing a specially-designed bathing suit and strappy, high-heeled sandals.

LEFT June 16, 1952, Taylor arrives at International Airport from London with her tabby kitten and her longhaired dachshund puppy for company. Her simple pleated knit dress, with a belt as usual, is accentuated with a delicately unobtrusive necklace and plain earrings.

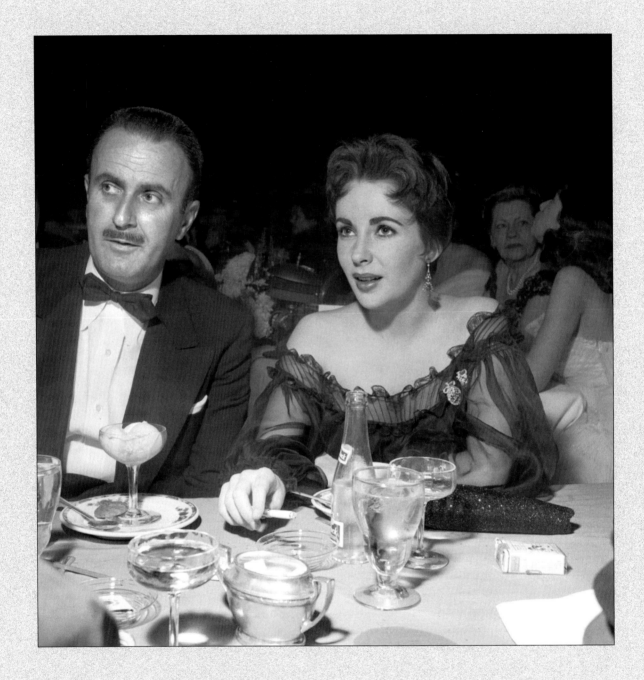

Wearing a sheer-sleeved, floaty off-the-shoulder evening gown,
Elizabeth attends the premier of the MGM movie *Hit the Deck* at
the Coconut Grove nightclub in January of 1954 in L.A.

RIGHT c.1953, in a tightly-corseted and strapless white satin
gown with crossover detail on the bust and an off-centre bow
underneath.

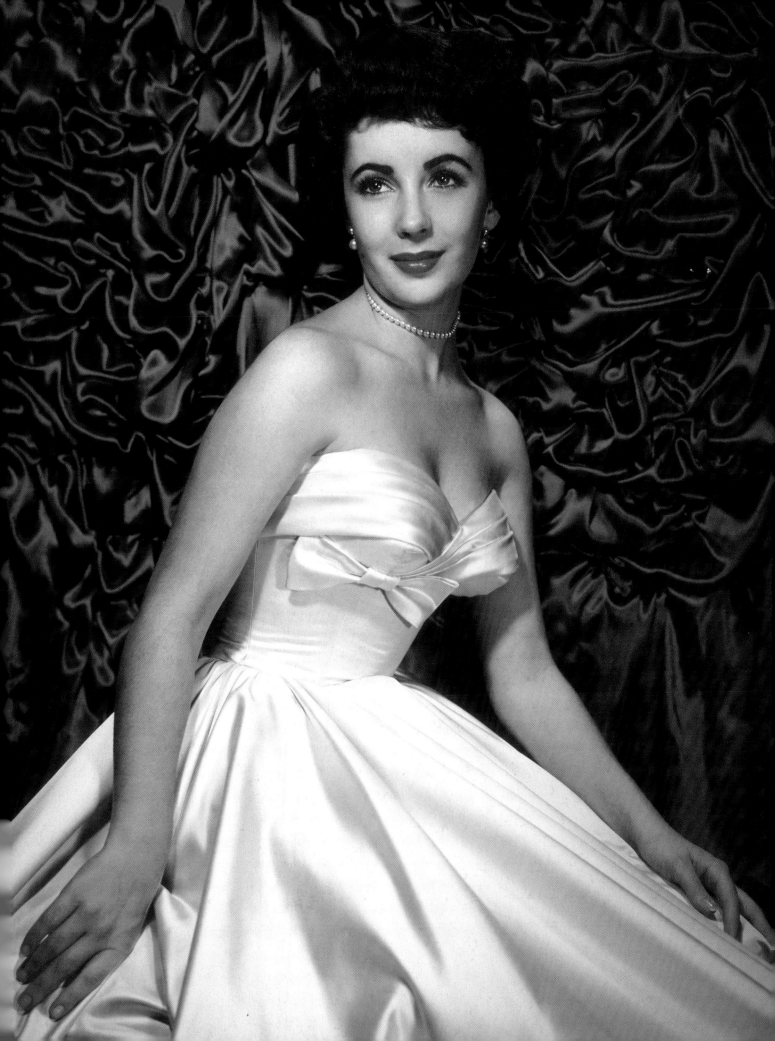

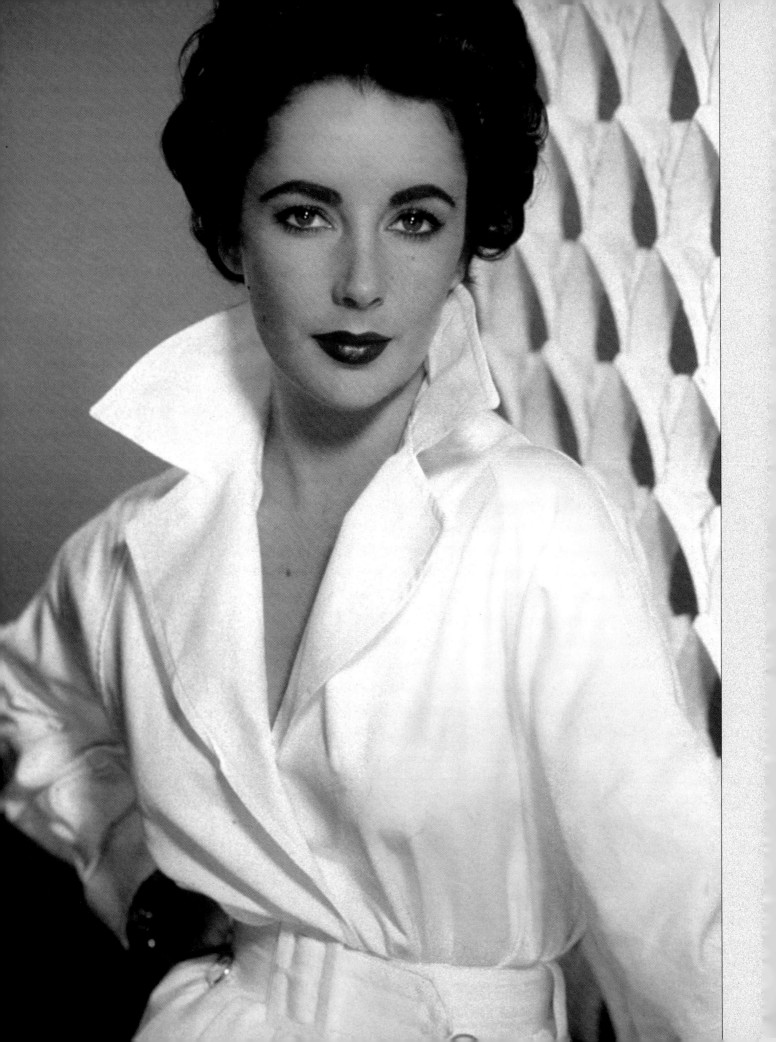

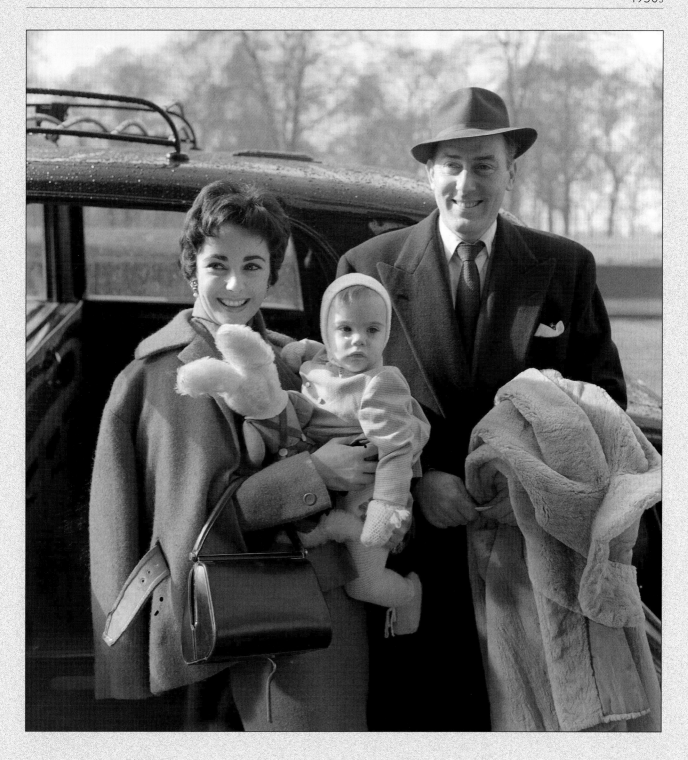

Film-star couple Elizabeth Taylor and Michael Wilding with their first son, Michael Wilding Jr, outside their London hotel before departing for the US in 1954.

LEFT 1954, Taylor poses for a portrait in a wide-collared white shirt-dress, cinched at the waist and with metallic loop detailing under the belt.

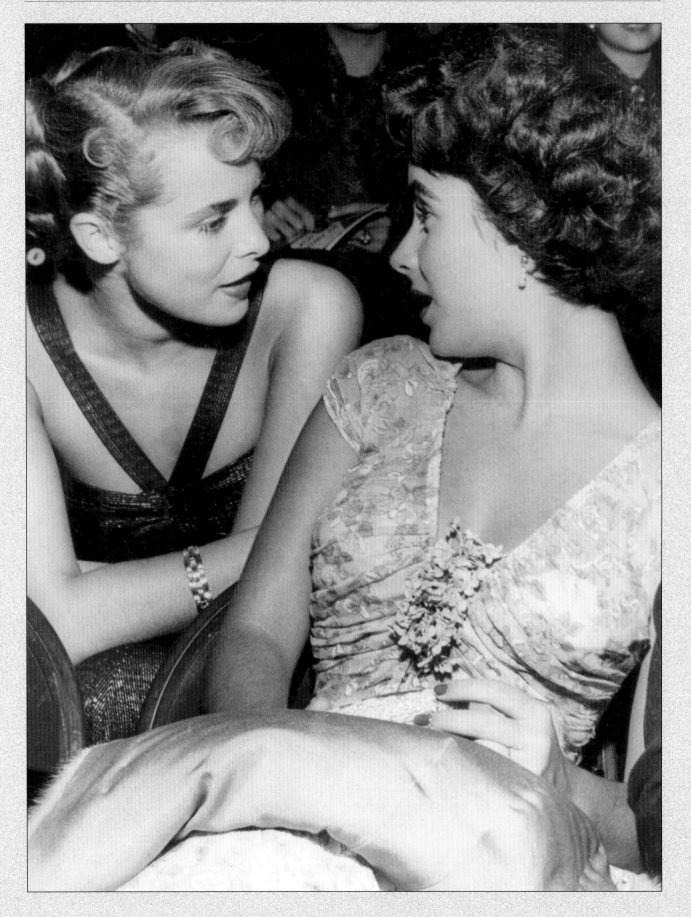

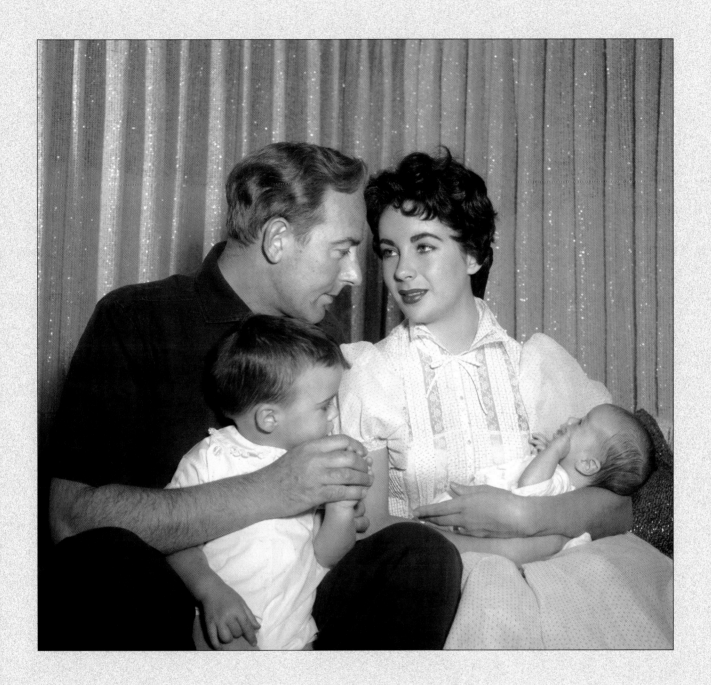

Michael Wilding and Elizabeth Taylor with their sons, Christopher
and Michael Jr., in 1956. Elizabeth looks the picture of maternal
modesty, in her delicate lace-and-ribbon, buttoned-to-the-neck
white dress, gazing at her husband. However, it would not be long
until this marriage ended.

LEFT With Janet Leigh in 1955, at an Ice Follies Ballet in Hollywood.

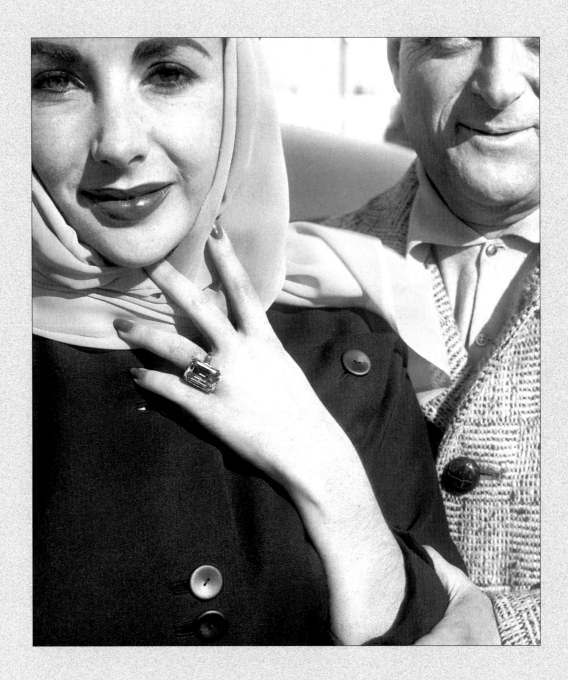

Gazing at her fondly and holding her arm, American film producer
Mike Todd escorts his new love to the plane at International
Airport. Elizabeth and Mike flew to Mexico where she was to
recuperate from spinal surgery. Elizabeth is wearing her gift from
Todd, a 29-and-⅞-carat diamond 'friendship ring'. They married
soon after.

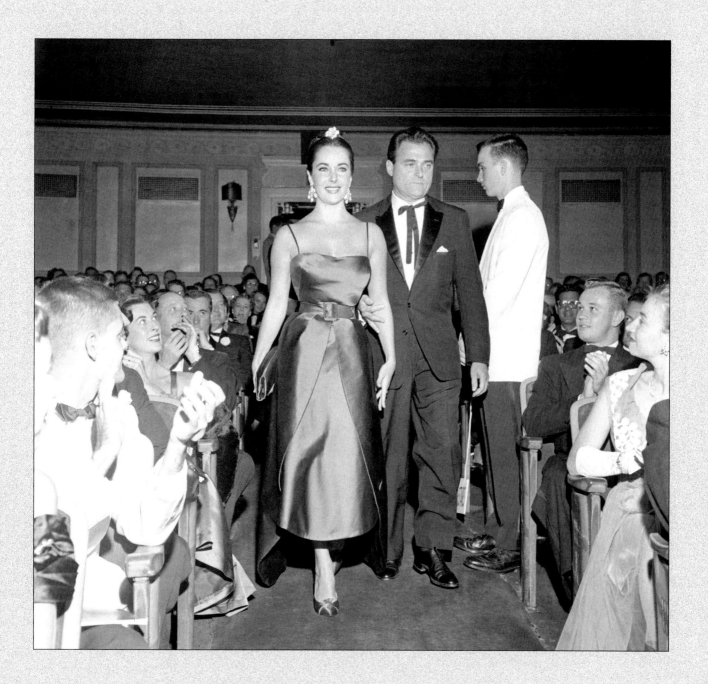

Wearing a beautiful satin evening gown with a wide buckled belt,
matching shoes, headdress and her diamond chandelier earrings,
Elizabeth Taylor is escorted to her seat in a theatre by Mike Todd.

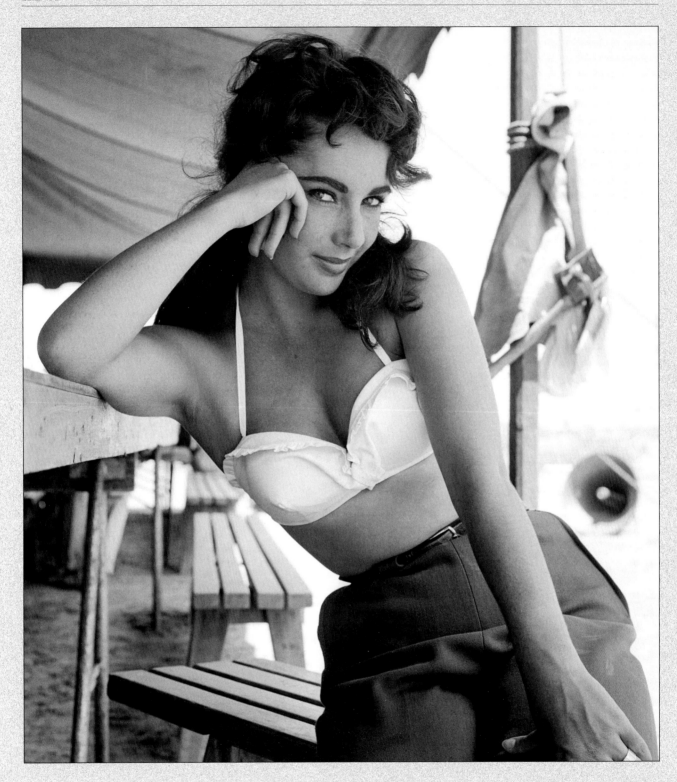

Taylor poses coquettishly on the set of director George Stevens'
1956 film, *Giant*, which was released on November 24, 1956.

RIGHT Elizabeth Taylor leaning against a dressing room trailer while
smoking a cigarette on the *Giant* set.

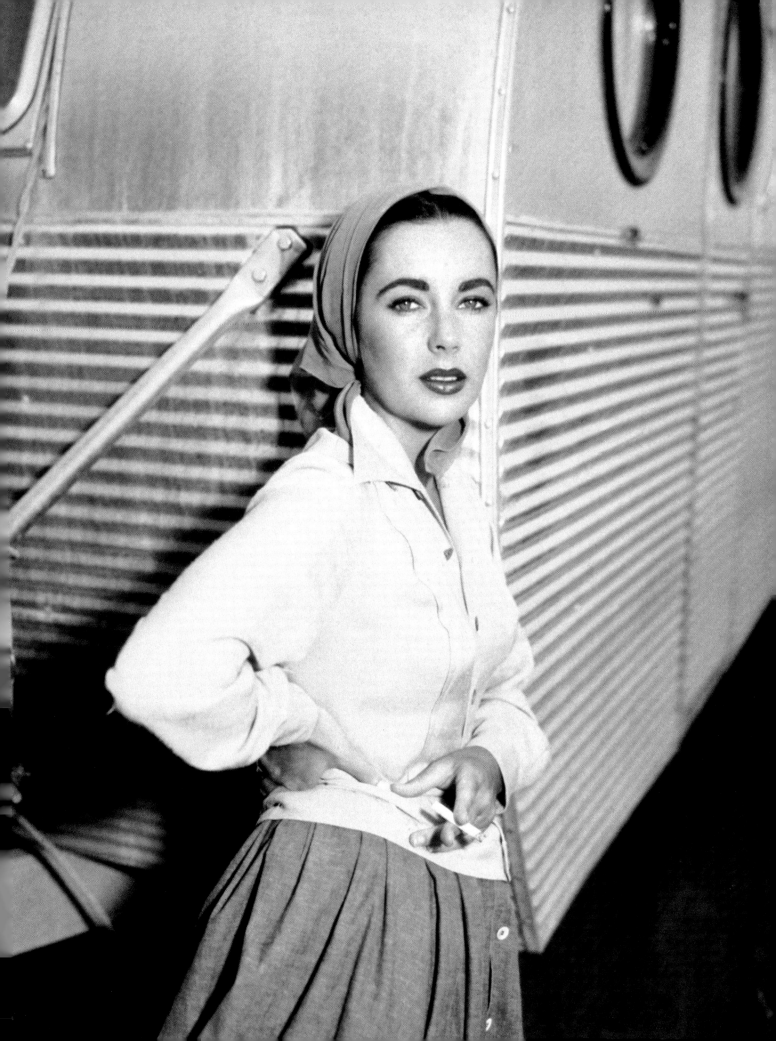

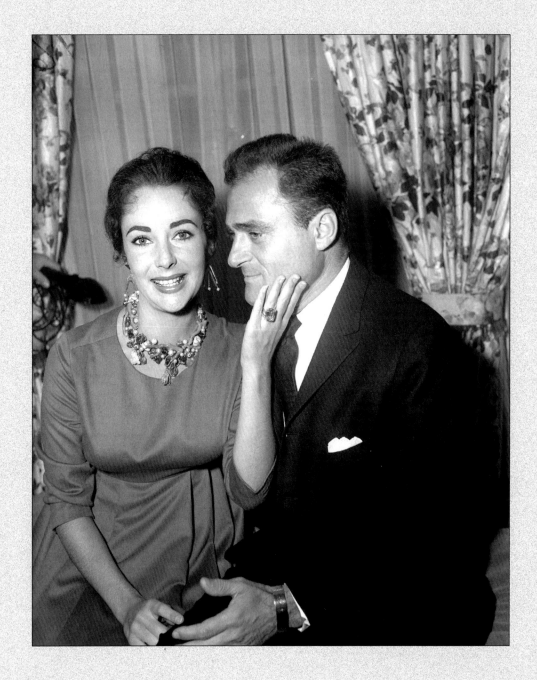

Elizabeth Taylor holds a press conference with her third husband,
American stage producer Mike Todd.

RIGHT In November of 1957, with husband Mike Todd and their new
daughter, Elizabeth Frances Todd.

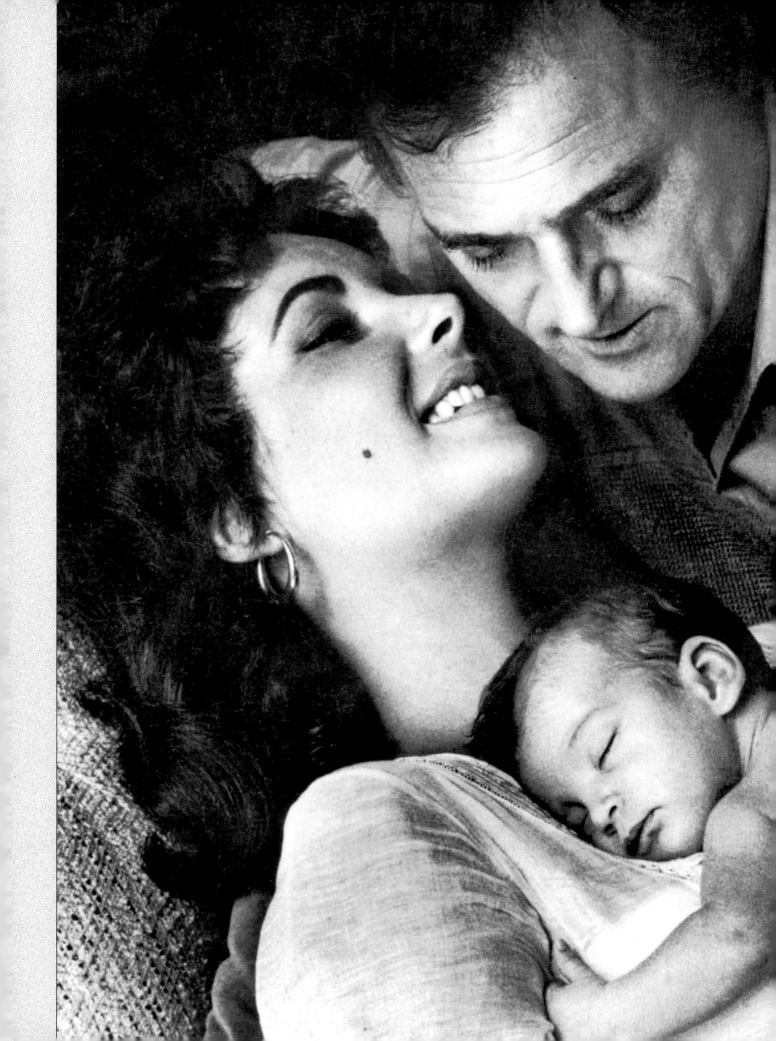

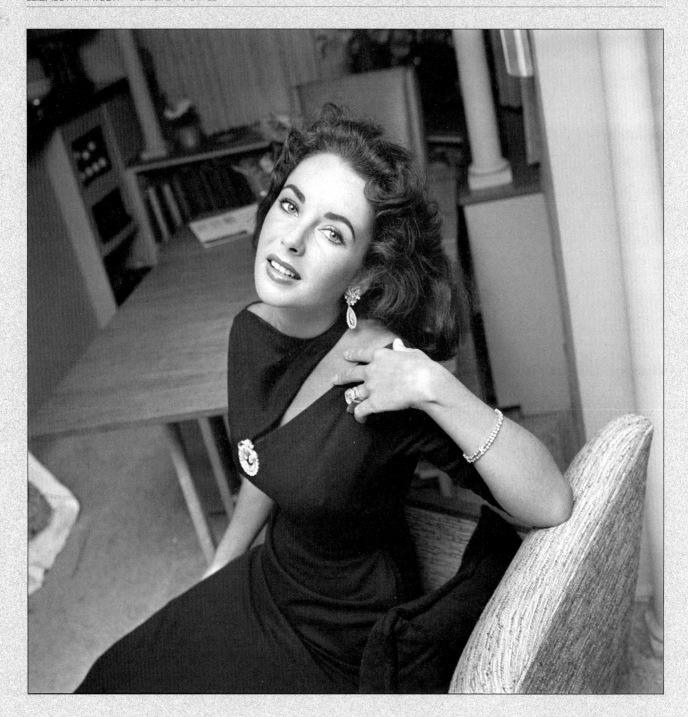

Wearing an elegantly-cut, perfectly fitted dress which partially exposes one shoulder, Elizabeth is photographed at her home in Beverly Hills in February of 1957.

RIGHT Elizabeth Taylor attending the 29th Academy Awards ceremony on March 27, 1957 in L.A. Her draped dress and plain wrap provide the perfect foil to her stunning gems; the diamond tiara was a gift from Mike Todd who presented it with the announcement: 'You are my queen and I think you should have a tiara.' Taylor famously used to wear the tiara swimming. Todd showered her with precious gifts during their relationship, including the iconic Cartier Ruby Suite, which she was often pictured wearing throughout her life. The suite comprised a ruby and diamond bib necklace with matching earrings and bracelet (p.63).

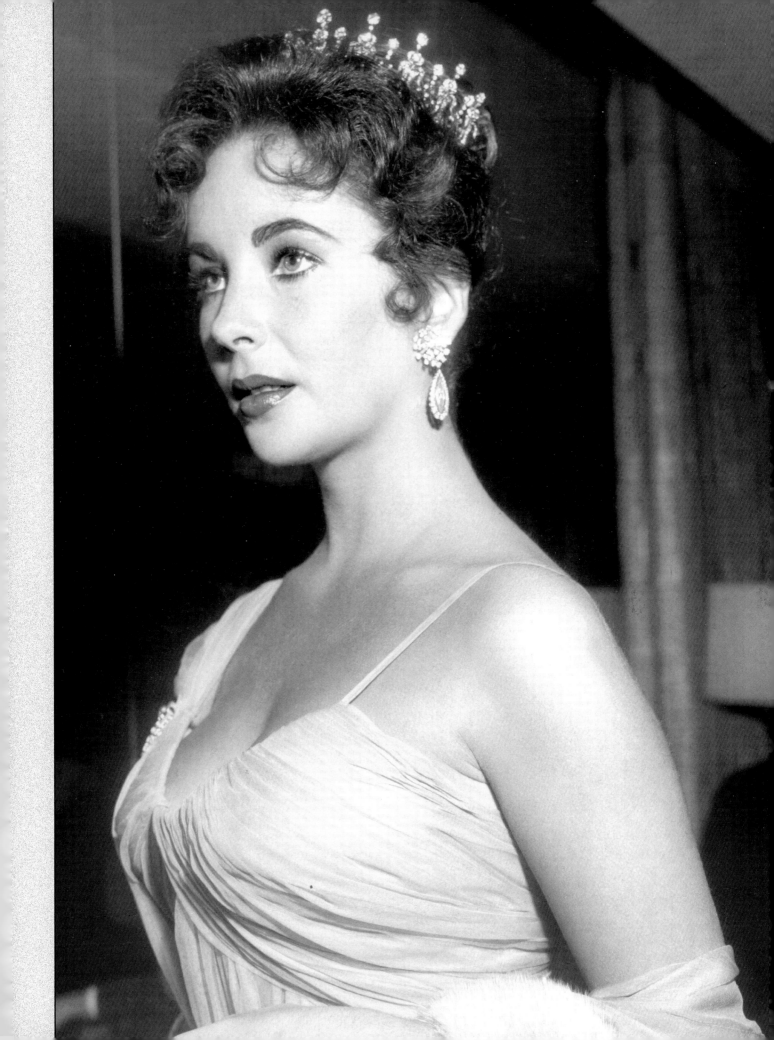

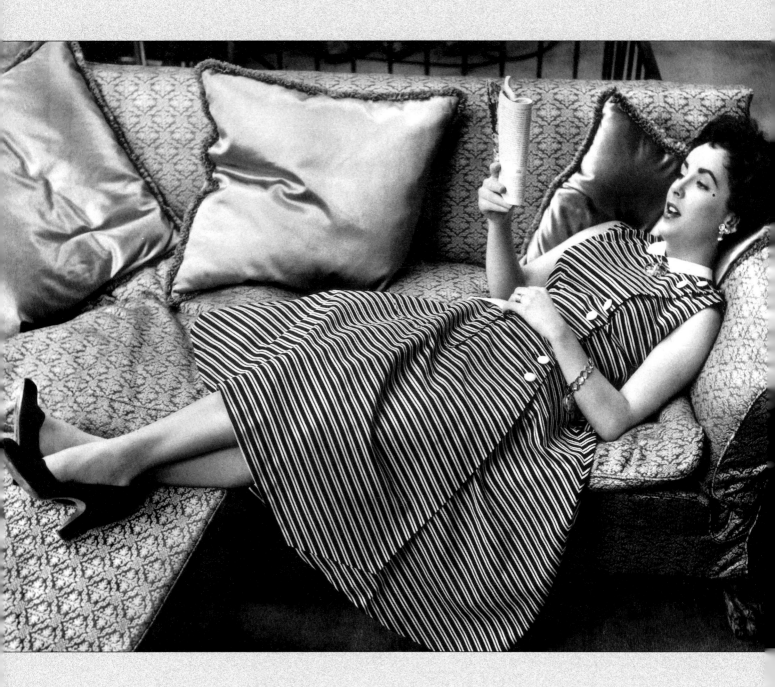

Photographed by Zoltan Glass in 1958, Taylor relaxes with a
magazine, wearing a full-skirted, sleeveless striped dress featuring
off-centre white buttons and a contrast-white collar, with black
court shoes.

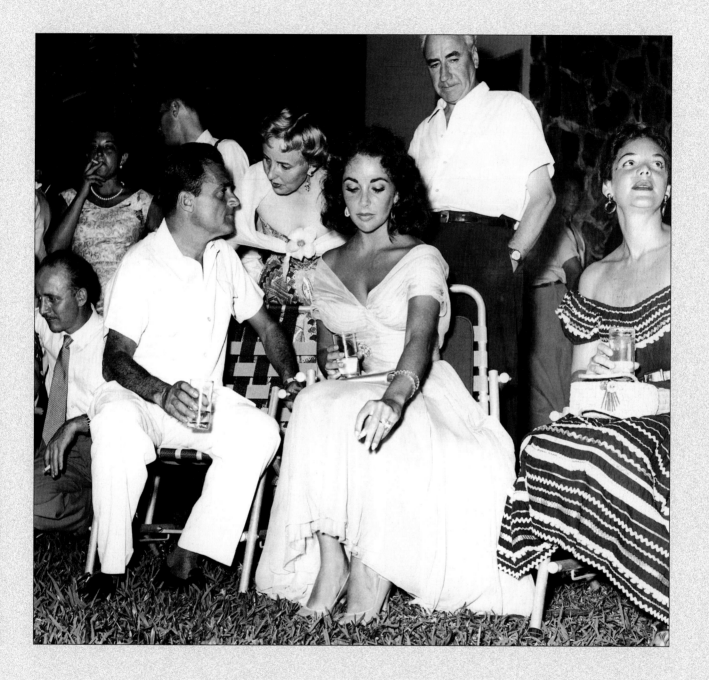

Early 1958: Taylor perches on a lawn chair in formal dress and heels with husband Mike Todd sitting next to her. Todd speaks with Taylor's mother Sara Taylor, while her father Francis Taylor stands behind with hands in his pockets.

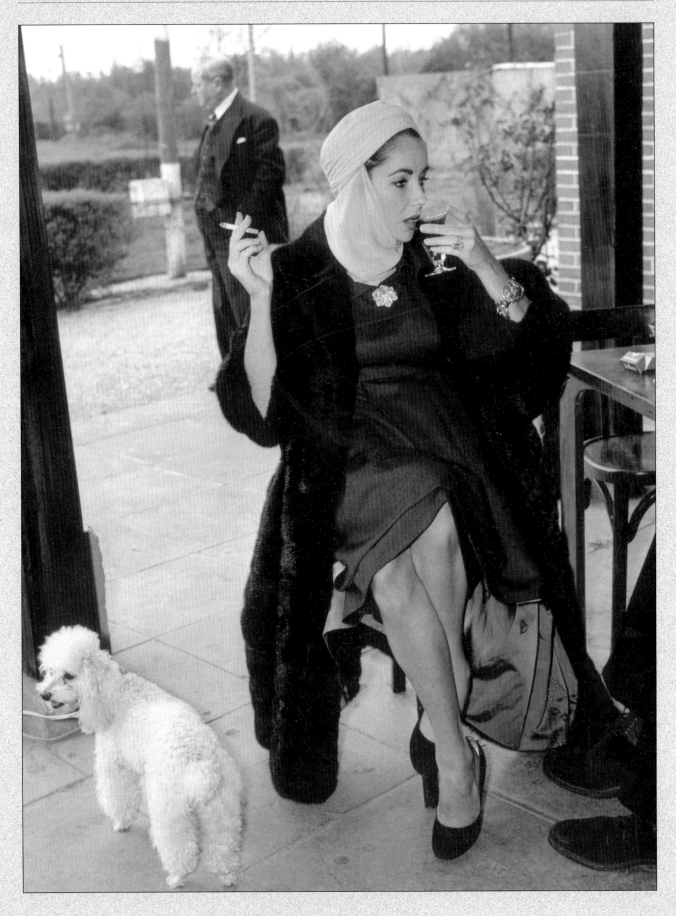

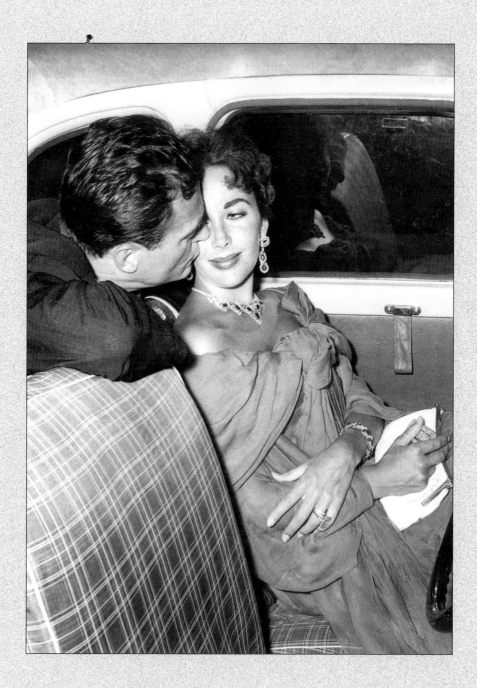

Taylor and Mike Todd shelter from the rain in a car. Elizabeth
is adorned with the Cartier Ruby Suite necklace, bracelet and
earrings.

LEFT Elizabeth Taylor sips a drink and smokes a cigarette during a
stop for interviews at Jersey airport en route to Nice.

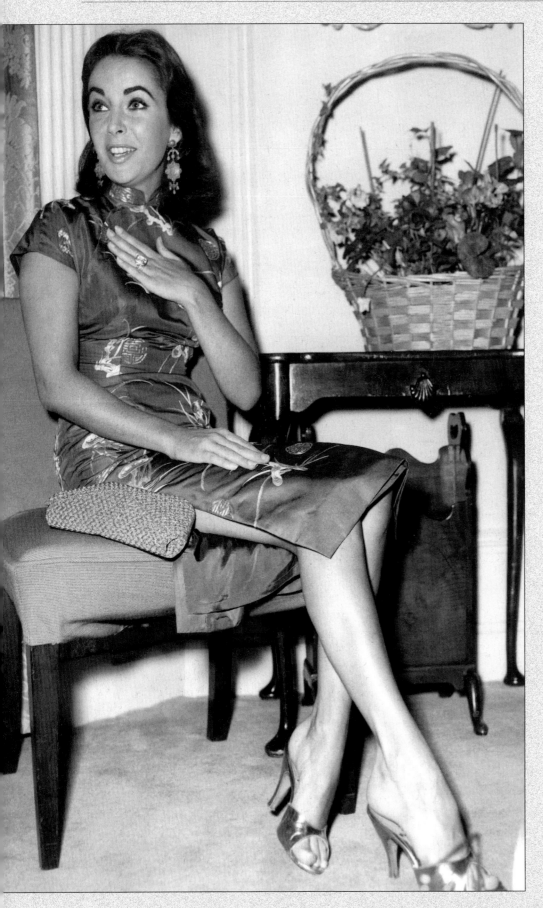

In January 1958 at a press reception
for her and her husband, held at
the Dorchester Hotel, Taylor wears
a striking silk cheongsam shift dress
with mandarin collar, and simple gold
heels.

RIGHT Eddie Fisher admiring Elizabeth
Taylor as she prepares in front of a
mirror before his show in April 1959.
The couple had just received news
that Eddie's wife Debbie Reynolds
would sign papers so he could get a
quick New York divorce.

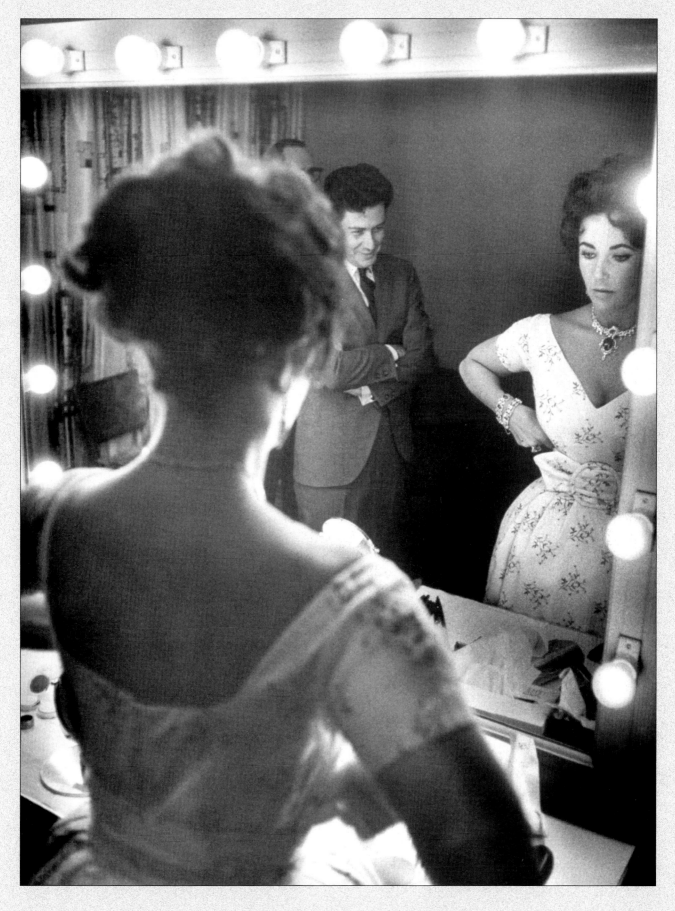

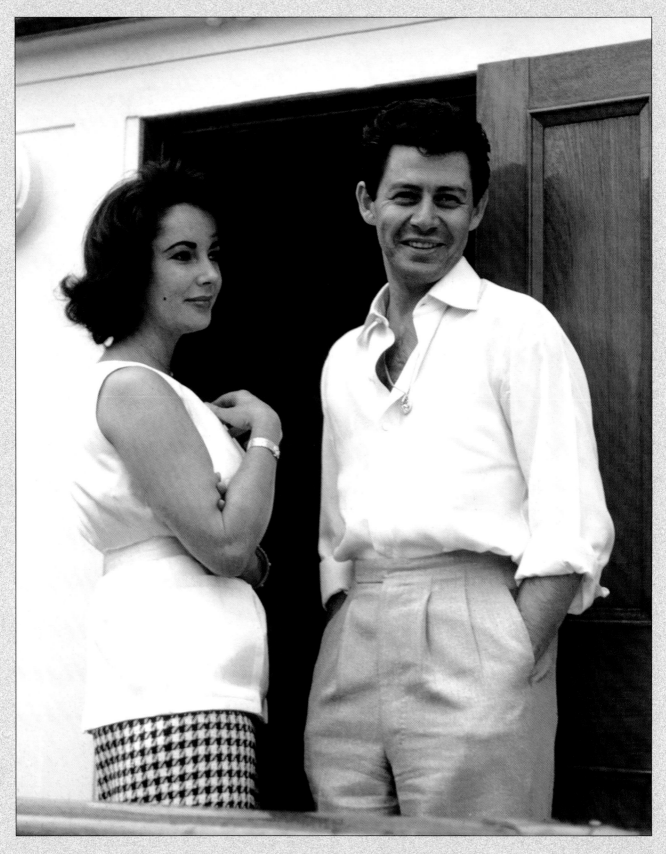

Both cool in crisp white, Elizabeth and her husband Eddie Fisher in May 1959.

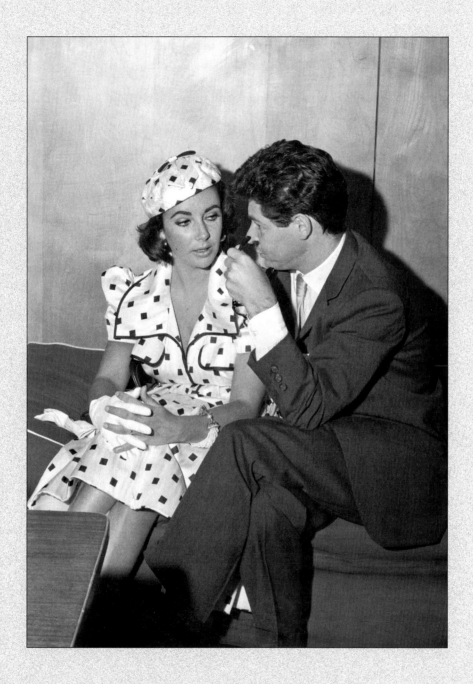

Elizabeth Taylor and her new husband Eddie Fisher at the Festival
Hall during their honeymoon in London, 8th June 1959. They were
attending a concert by Texan pianist Van Cliburn, a friend of Fisher.

1960s

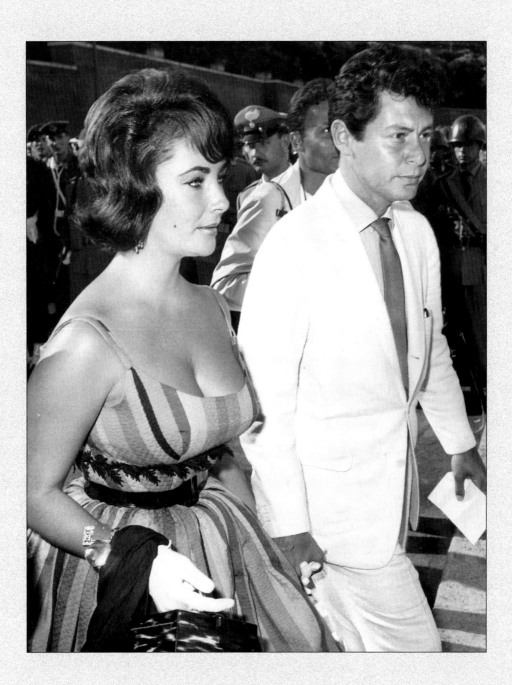

In August 1960, Taylor with Eddie Fisher attending the opening
ceremony of the Olympic Games in Rome.

RIGHT With Eddie Fisher, Taylor wears a black and white checked
outfit with white wide brimmed hat and gloves.

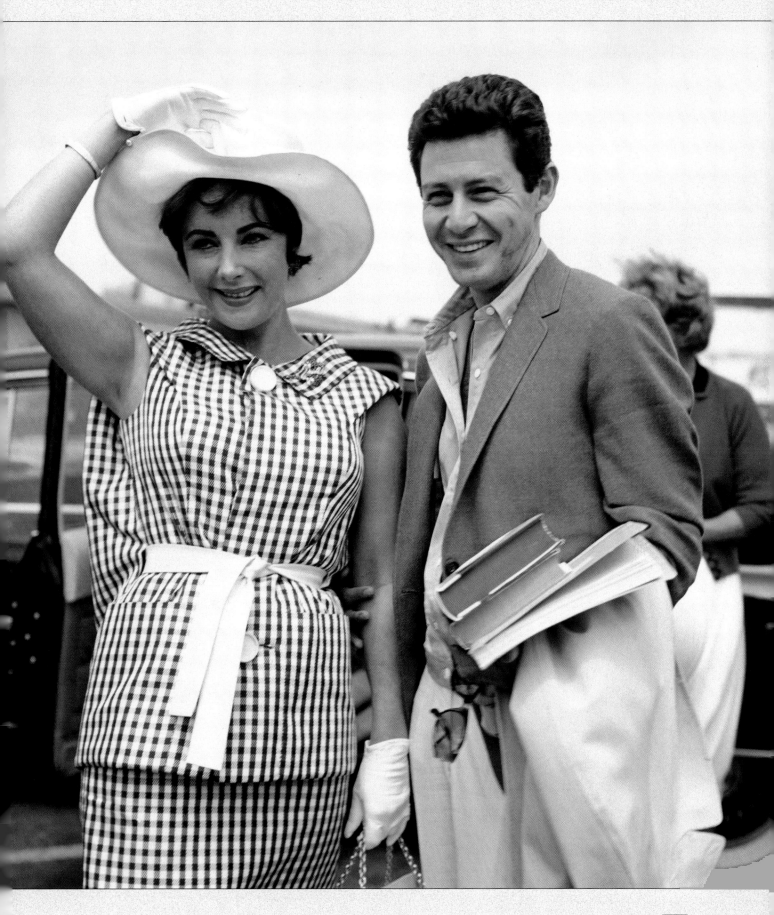

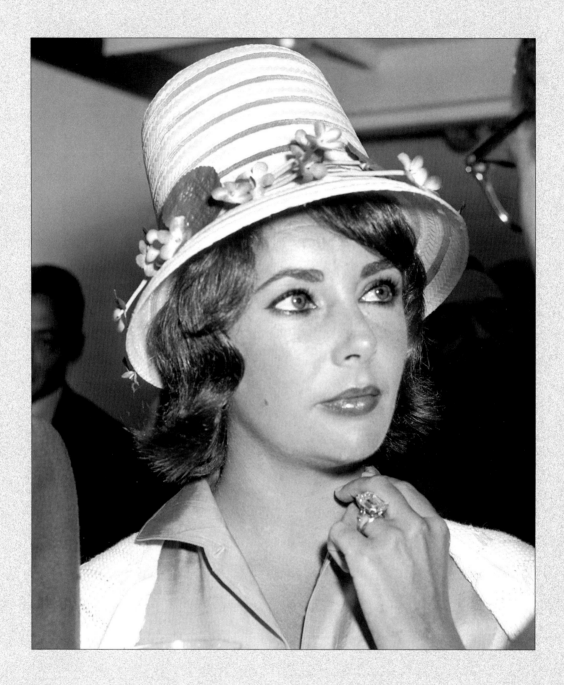

Boarding the *Leonardo da Vinci* on August 16, 1960, Elizabeth was
heading for Italy where she was to make *Cleopatra*.

RIGHT A portrait shot in 1960.

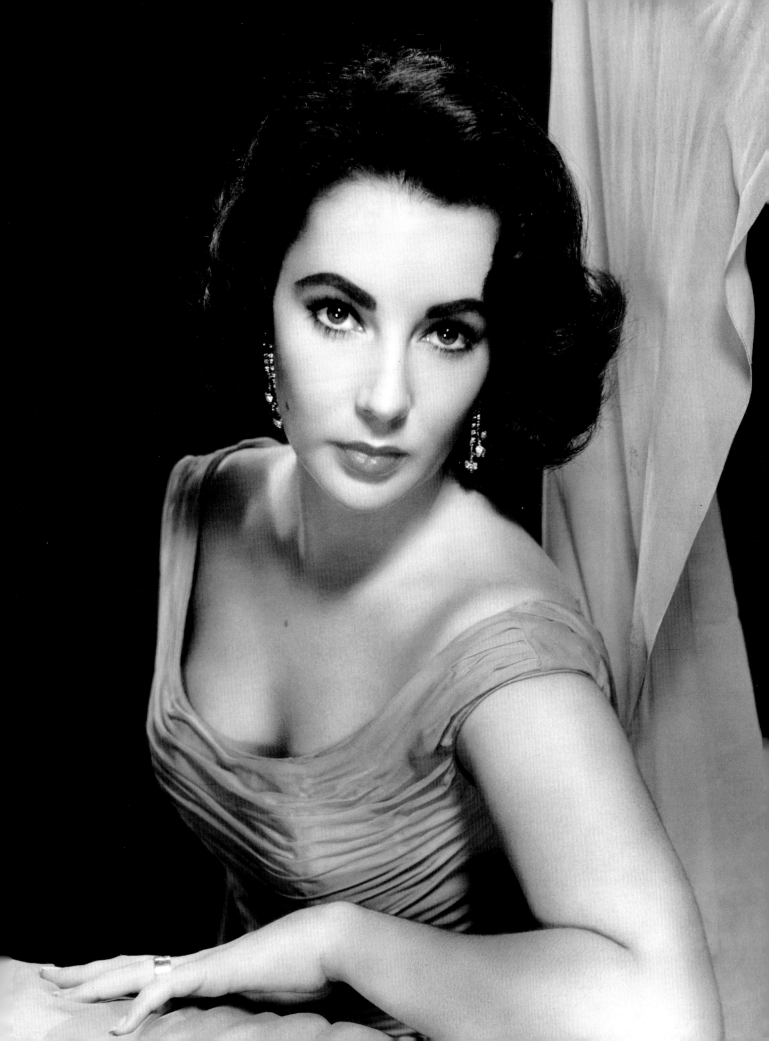

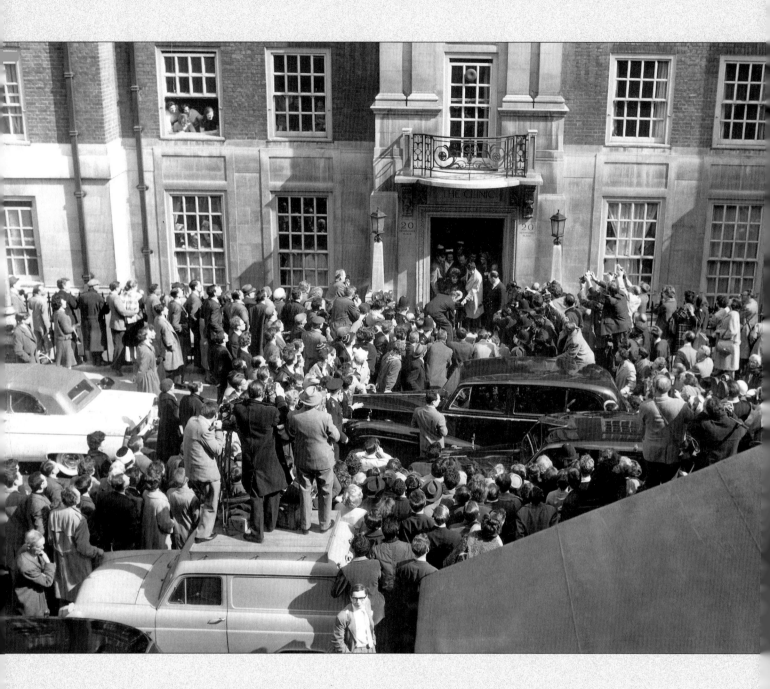

Crowds gather outside the London clinic where Elizabeth received
treatment for pneumonia, to catch a glimpse of her leaving on
March 23, 1961.

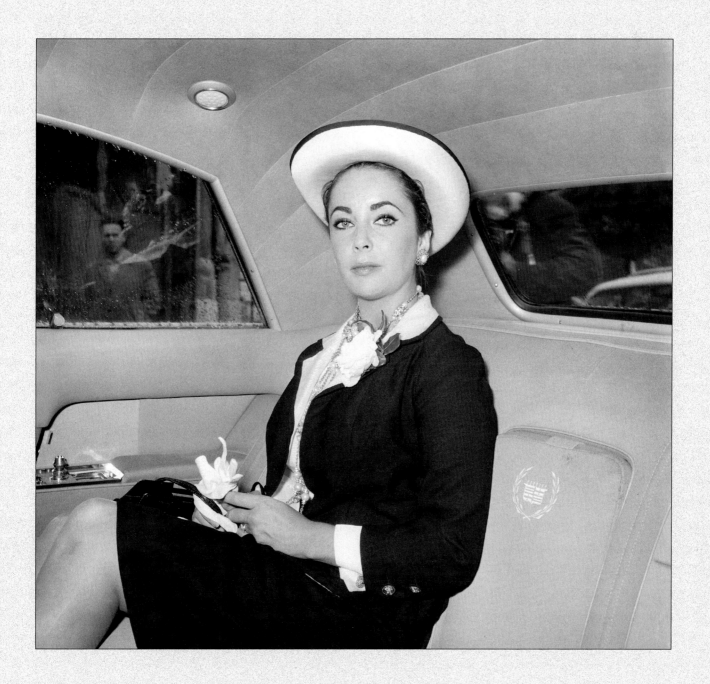

Elegantly outfitted with a matching hat and suit, Elizabeth Taylor is
photographed in a car in Paris during the 1960s.

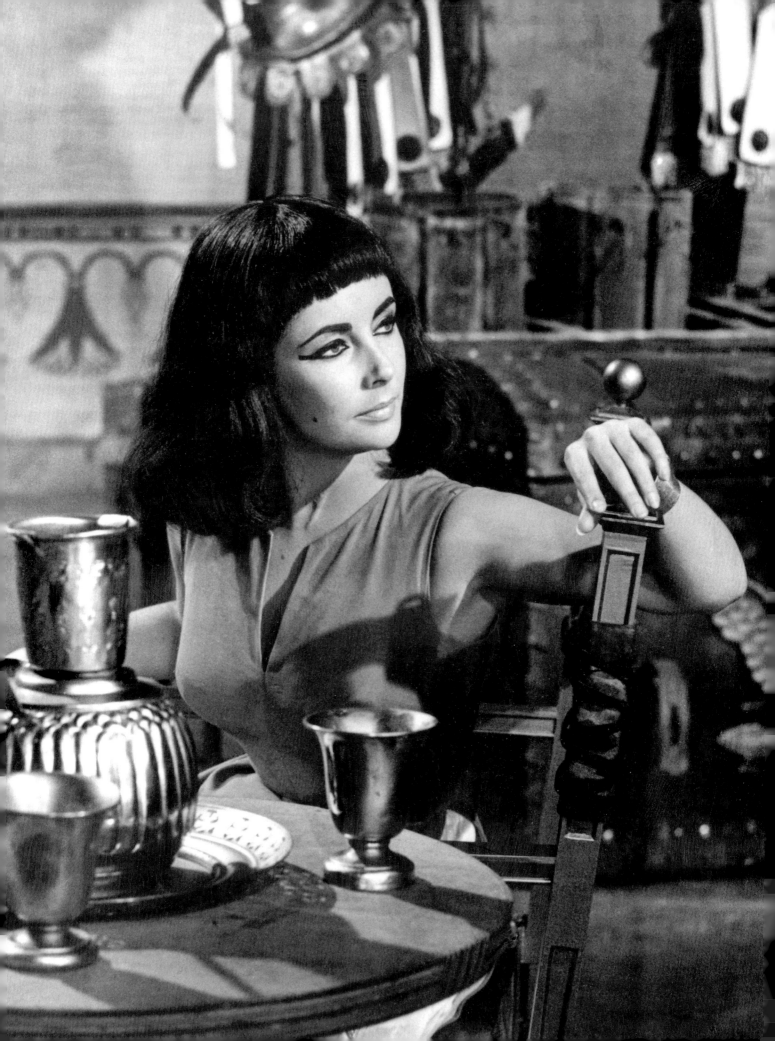

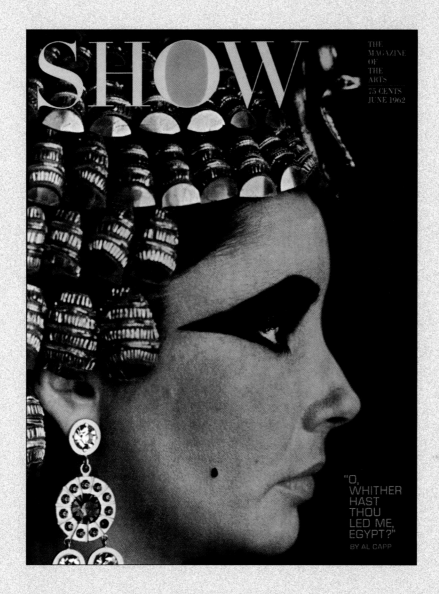

Elizabeth Taylor as Cleopatra, on the cover of *Show Magazine* in Rome, Italy in June 1962.

LEFT 22 November 1961 in the 20th Century Fox production of Joseph L Mankiewicz's film *Cleopatra*.

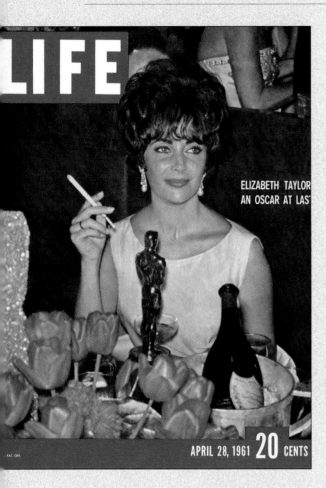

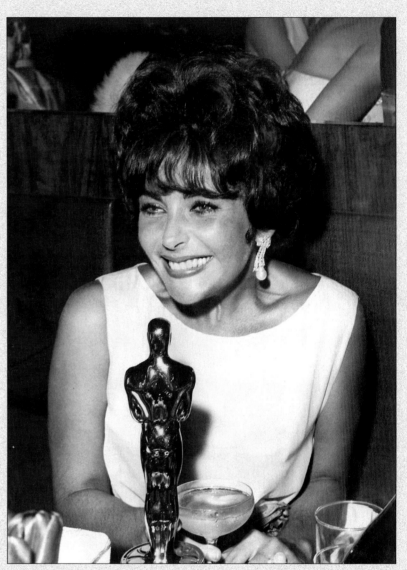

On the cover of LIFE magazine, April 28, 1961;
Taylor smokes a cigarette at a post-Academy
Awards party, her Oscar statuette on the table in
front of her. The headline reads: 'Elizabeth Taylor:
An Oscar at Last'.

RIGHT A more candid shot of Elizabeth with
her Oscar, her tracheotomy scar clearly visible
following her severe battle with pneumonia in
spring of 1961. The Awards vote was widely
thought to have been influenced by her illness,
Taylor herself commenting later, 'Any of my three
previous nominations were more deserving. I
knew it was a sympathy award, but I was still
proud to get it'.

FAR RIGHT The dress Elizabeth wore to the
Academy Awards featured a intricate embroidery
on the skirt with a nipped in waist and bow-and-
flower detail belt.

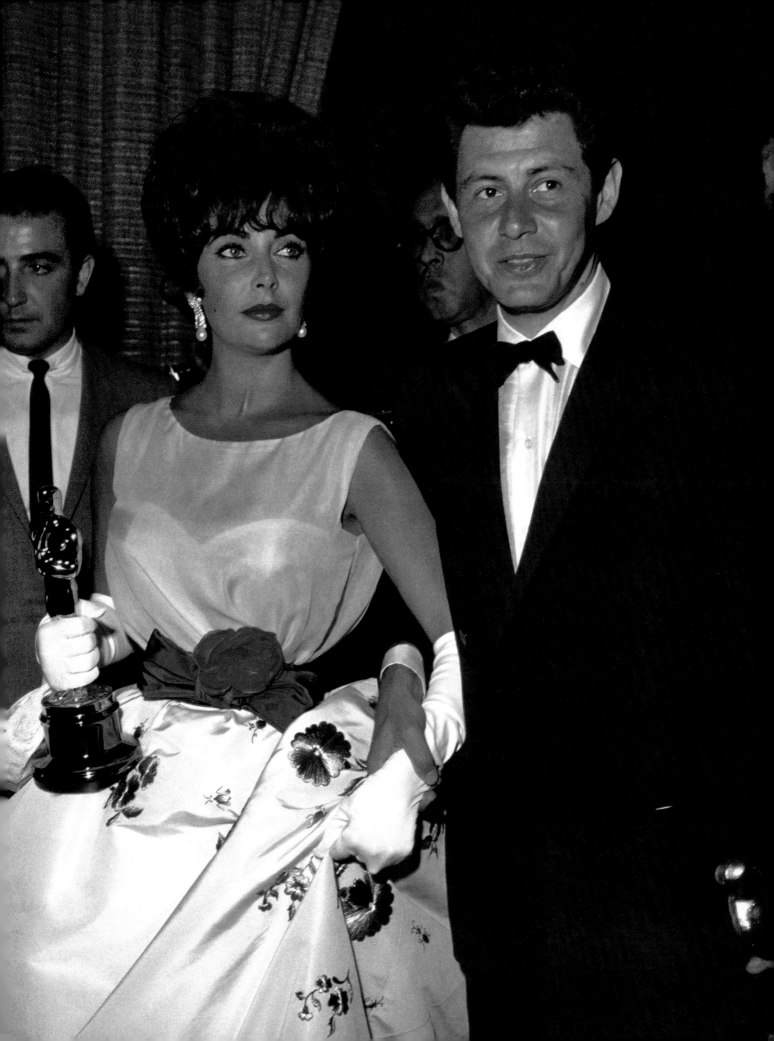

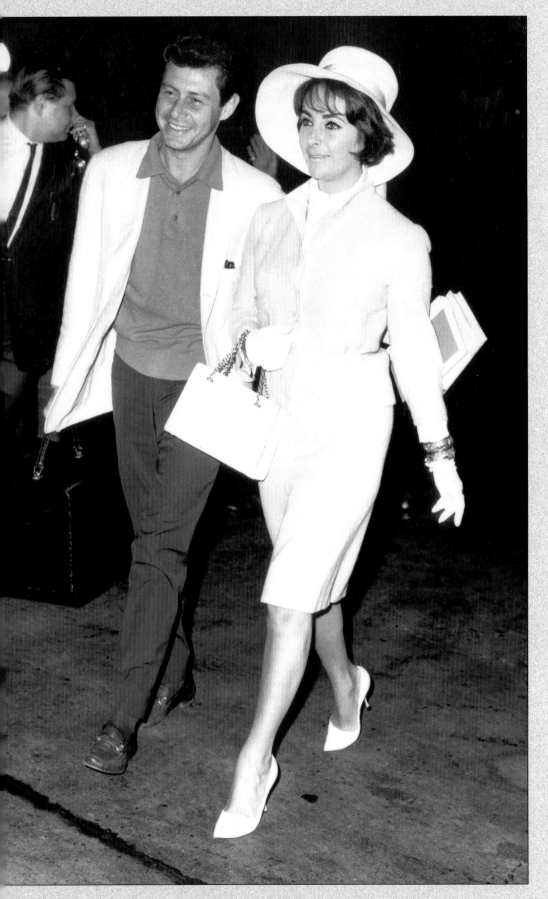

Taylor and Eddie Fisher at Heathrow Airport in 1961. Elizabeth is elegantly turned out for travel, in a fitted suit with matching shoes, hat and bag.

RIGHT At a formal event with Eddie Fisher in 1961, Elizabeth wears a draped evening gown, crossed over on the bust and fixed with a diamond brooch. Her diamond chandelier earrings were antique; she wore them first in 1959, having discovered them in a Paris boutique where they sparkled with paste gems. A few months later, preparing for a party in New York, she commented to her then husband Mike Todd that there was something wrong with the earrings – he told her that he had had the glass replaced with real diamonds.

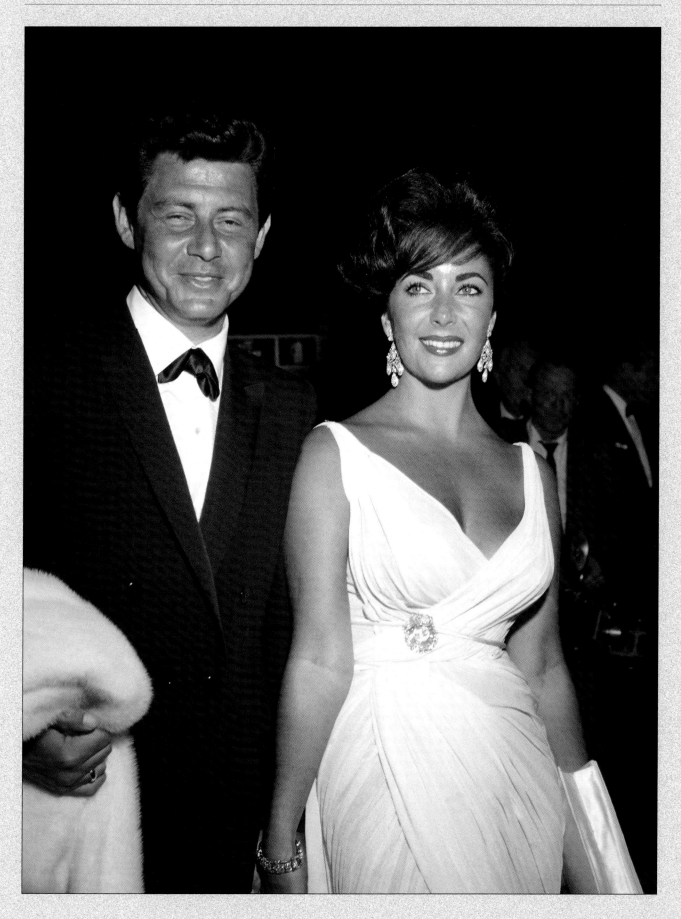

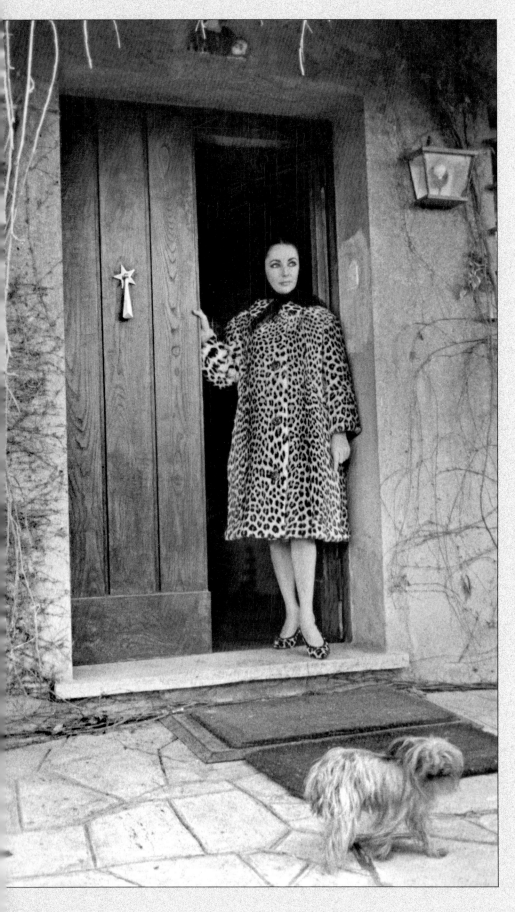

LEFT Elizabeth Taylor at the villa of the Via Appia after leaving the American Hospital Salvatore Mundi on February 19, 1962 in Rome, Italy. The luxurious leopard coat and matching shoes are toned down ever so slightly by her conservatively modest black headscarf.

RIGHT December 1962: resplendently feline in a fur hat and matching collar.

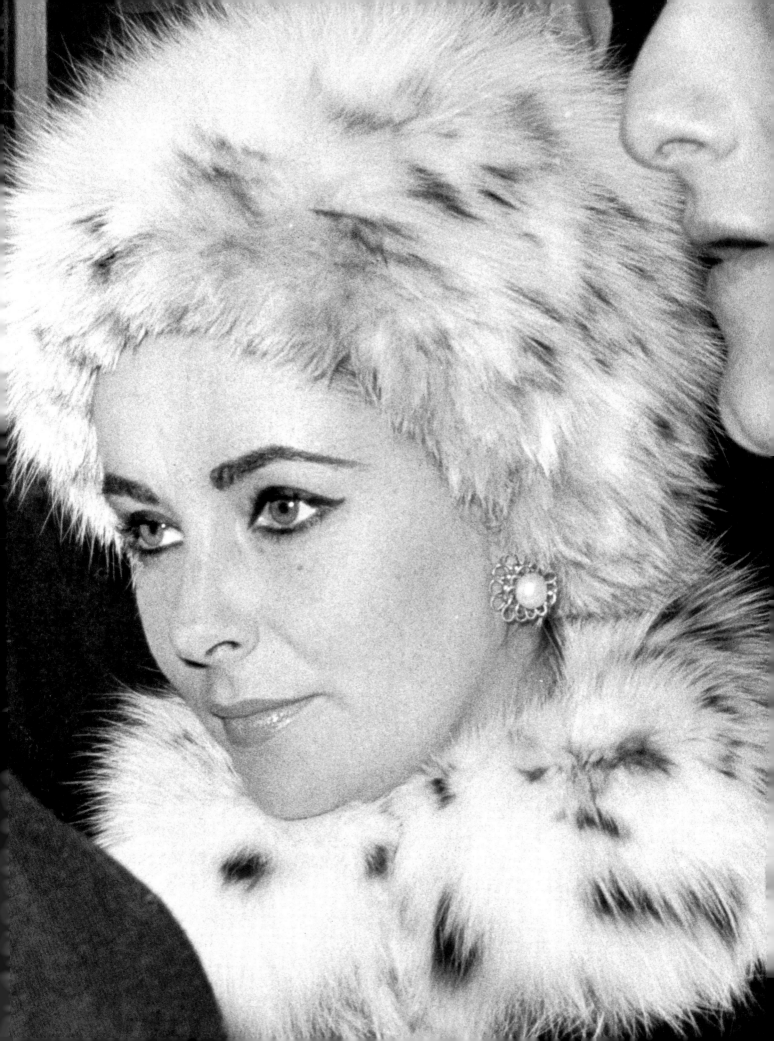

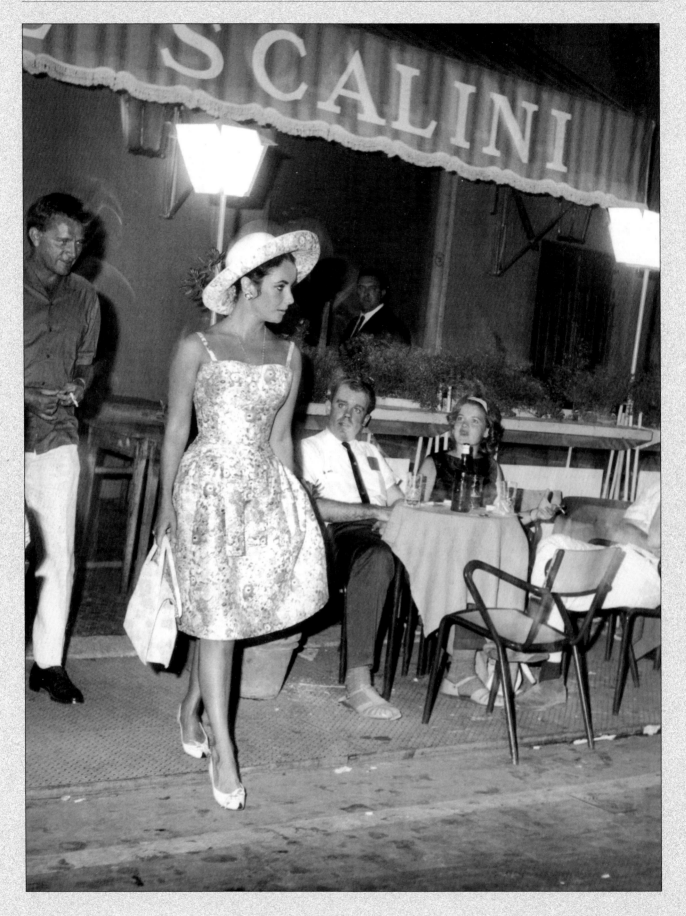

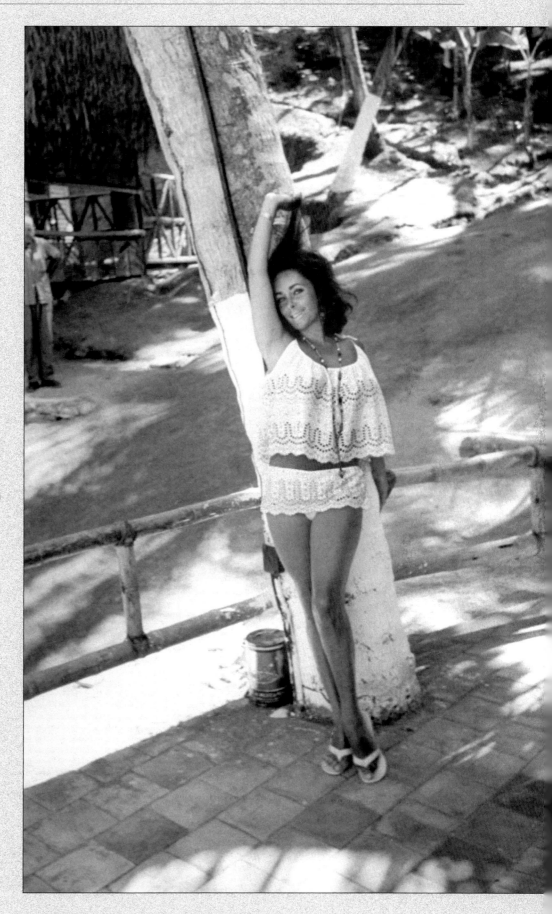

LEFT Looking like she has just stepped out of a 1960s 'resort wear' fashionplate, Elizabeth leaves *Tre Scalini* restaurant in the Piazza Navona in Rome, wearing a short floral dress with a fitted bodice, thin shoulder straps and a matching large-brimmed hat.

RIGHT On set of *The Night of the Iguana*, she poses in a bathing suit.

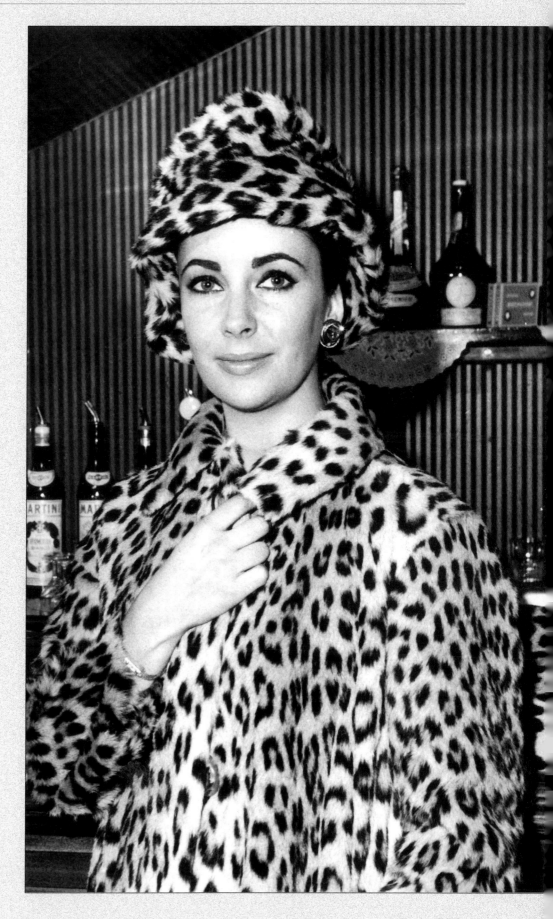

LEFT Happy and relaxed on set during filming of *The Night of the Iguana* in 1963.

RIGHT In a bar, Taylor is photographed in her leopard-skin coat and hat.

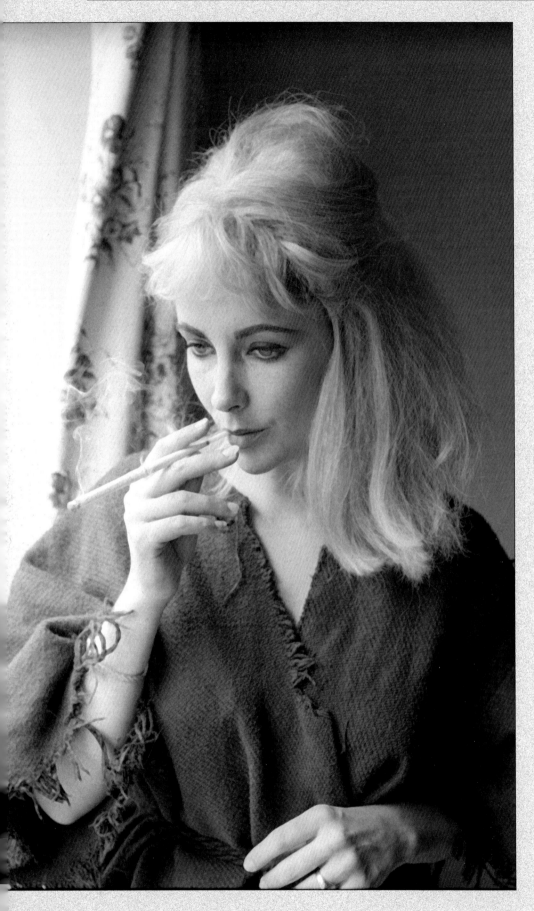

Elizabeth poses in a blonde wig, while smoking a cigarette and fixing her makeup in a 1963 photo session.

RIGHT March 3, 1965, Elizabeth Taylor arrives at London Airport wearing a hooded dark fur coat with substantial toggle fastenings.

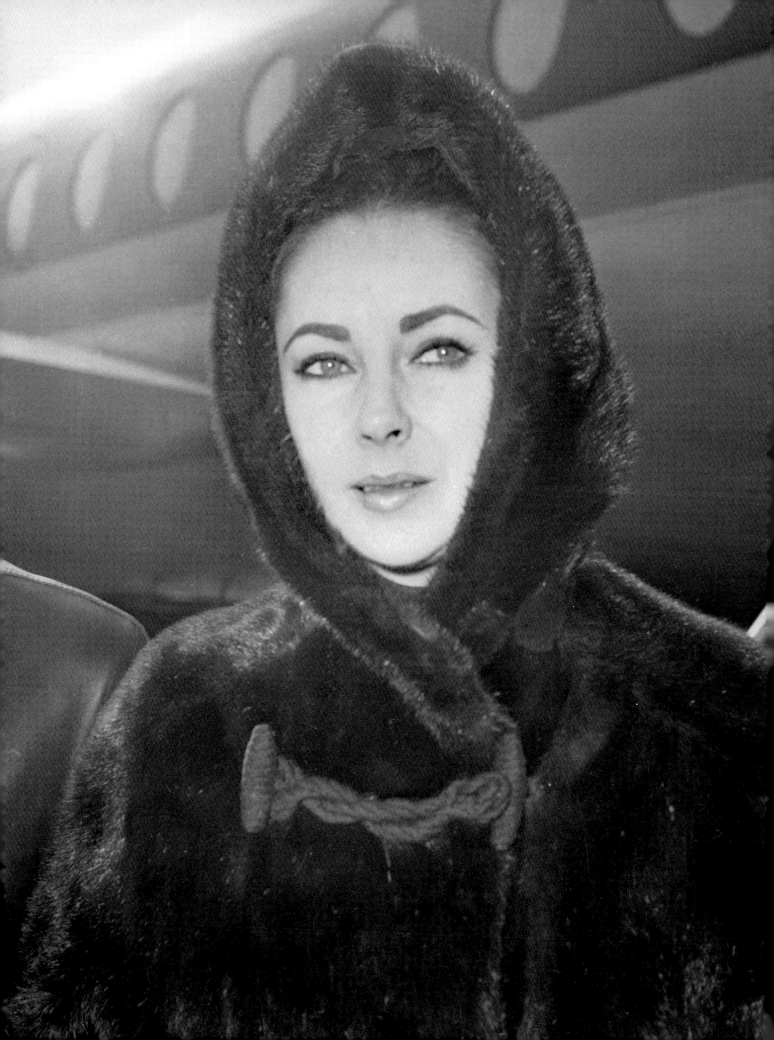

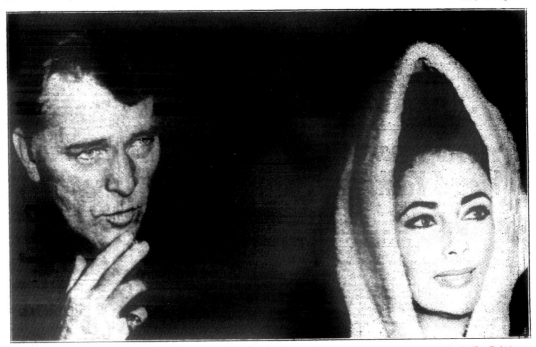

AT LAST: LIZ AND BURTON WED

FINAL ★★

DAILY NEWS
NEW YORK'S PICTURE NEWSPAPER ®

5¢

Vol. 45. No. 227 Copr. 1964 News Syndicate Co. Inc. New York, N.Y. 10017, Monday, March 16, 1964★ WEATHER: Fair and mild.

—— Story on **Page 2**

Murphy Vows City Won't Become A Civil Rights 'Battleground'

—— Story on **Page 3**

'Elizabeth Burton and I Are Happy.' Richard Burton and Liz Taylor, shown in Toronto recently, finally climaxed their international romance yesterday by getting married in Montreal. "Elizabeth Burton and I are very, very happy," said the Welsh actor after the ceremony, number 5 for Liz and 2 for Burton. *Story and other picture on page 2* (Associated Press Wirefoto)

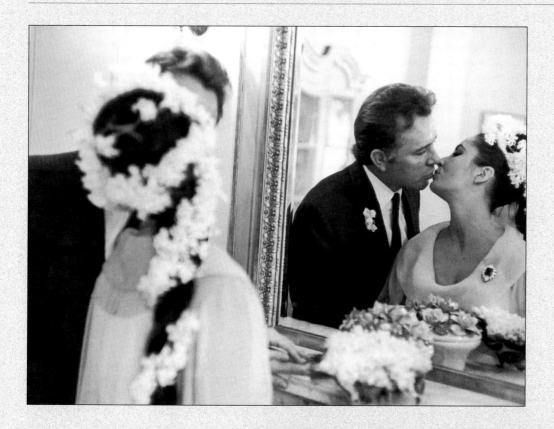

LEFT Having met on the set of *Cleopatra* in Italy, the love affair between Elizabeth Taylor and Richard Burton caused an international scandal. They became Hollywood's most glamorous couple, marrying in Montreal on March 15, 1964 as soon as they extricated themselves from their previous partners. It was Burton's second marriage, and Taylor's fifth. Following the ceremony, Richard made the statement: 'Elizabeth Burton and I are very, very happy'.

Richard Burton takes a break from his cigarette to kiss his new bride. Elizabeth's hair is festooned with flowers and she wears a floaty yellow chiffon gown, with matching yellow bows in her hair.

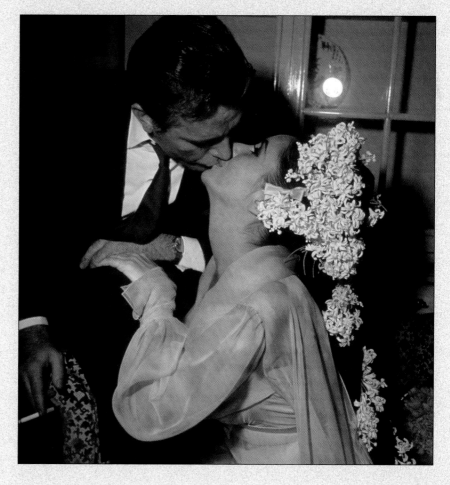

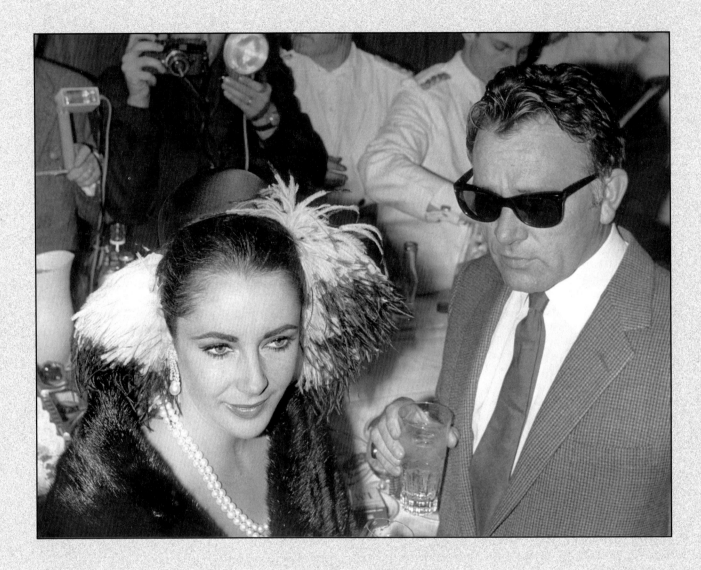

13 October 1964: Adorned with fur, pearls and an elaborate
feather headress, Elizabeth with Richard at a press reception in
Paris, where she was filming *The Sandpiper*.

Taylor and Burton chatting in a bar during a visit to Canada in the 1960s.

BELOW Elizabeth Taylor and Richard Burton in the 1960s.. She wears an elaborate hairdo and a glamorous fur-trimmed coat, offsetting the striking Bulgari diamond-and-emerald necklace and earring set, which Burton had bought for her in 1962 on a break from shooting *Cleopatra*. Taylor said that Burton would give her 'It's a beautiful day' presents or 'Let's go for a walk' presents, and that she came to think of these as 'It's Tuesday, I love you' gifts.

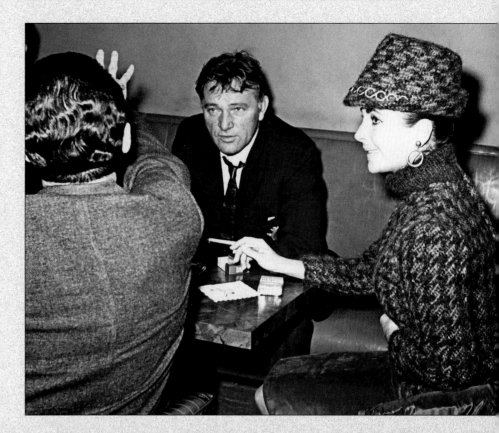

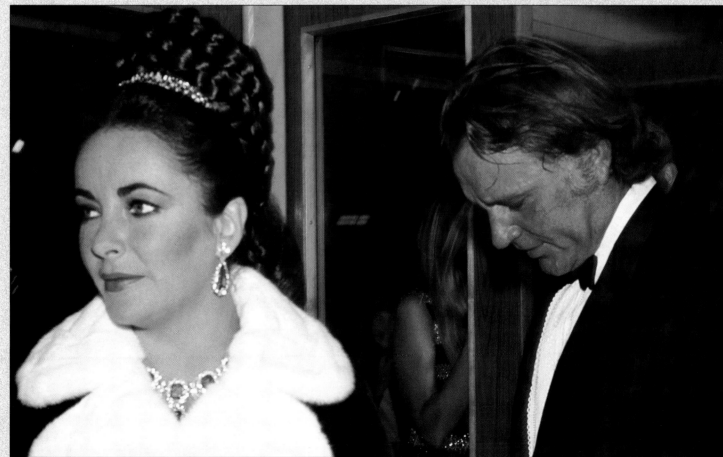

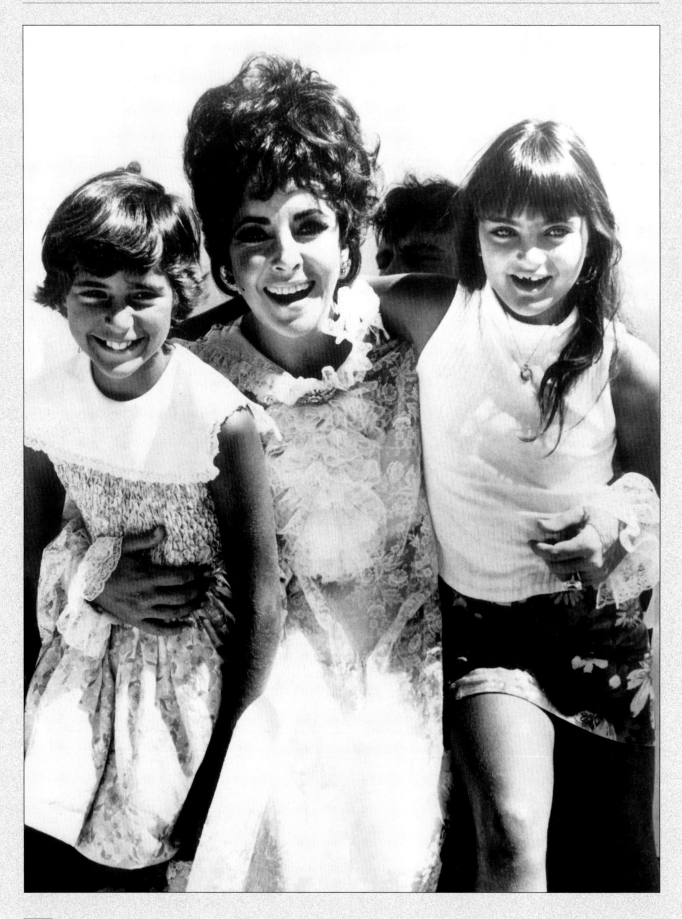

Natural, relaxed and happy, Elizabeth and Richard on vacation with
their children on the French Riviera in 1965.

LEFT Taylor delighted with the company of her two daughters,
c.1965. Liza (right) was her baby with Mike Todd, and Taylor and
Burton adopted Maria (left).

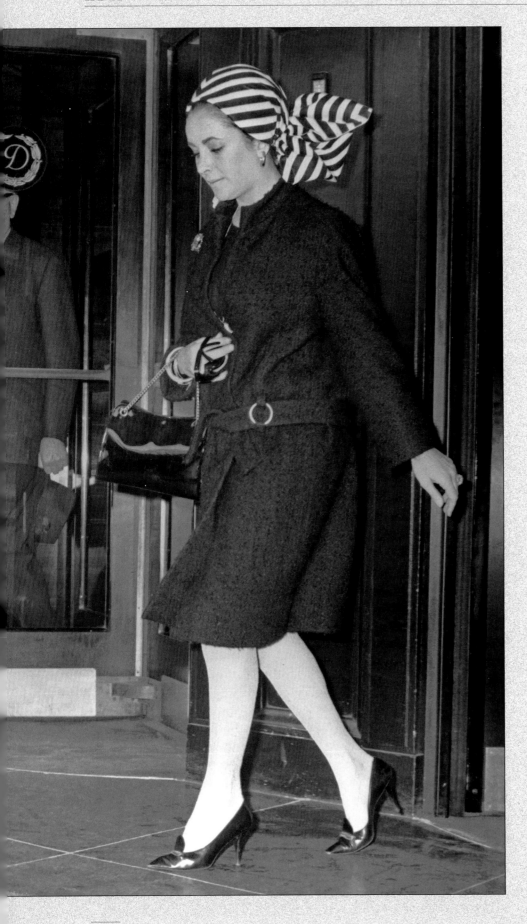

Leaving the Dorchester Hotel on April 24, 1965, Taylor's striking striped headscarf contrasts beautifully with the pared-back elegance of her simple belted coat, subtle heels and modest bag.

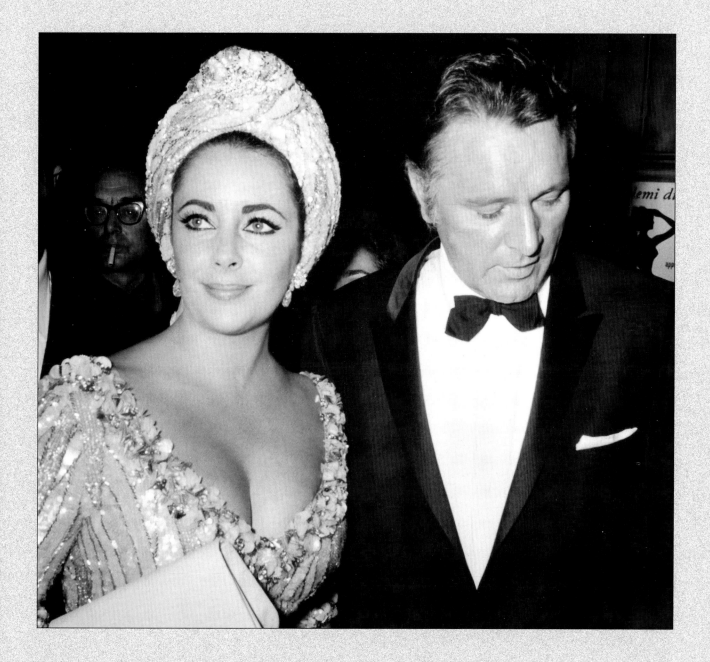

With Burton at the Sistina Theatre in Rome, October 5, 1966. The couple received the *Maschere d'Argento* for best non-Italian actors. The two shared the limelight in three successful films: *Cleopatra*, 1963; *Who's Afraid of Virginia Woolf*, 1965; and *The Taming of the Shrew*, 1966. Elizabeth shines in a sequin-encrusted formal gown, with an extra-elaborately decorated plunging neckline, and a matching shimmering turban.

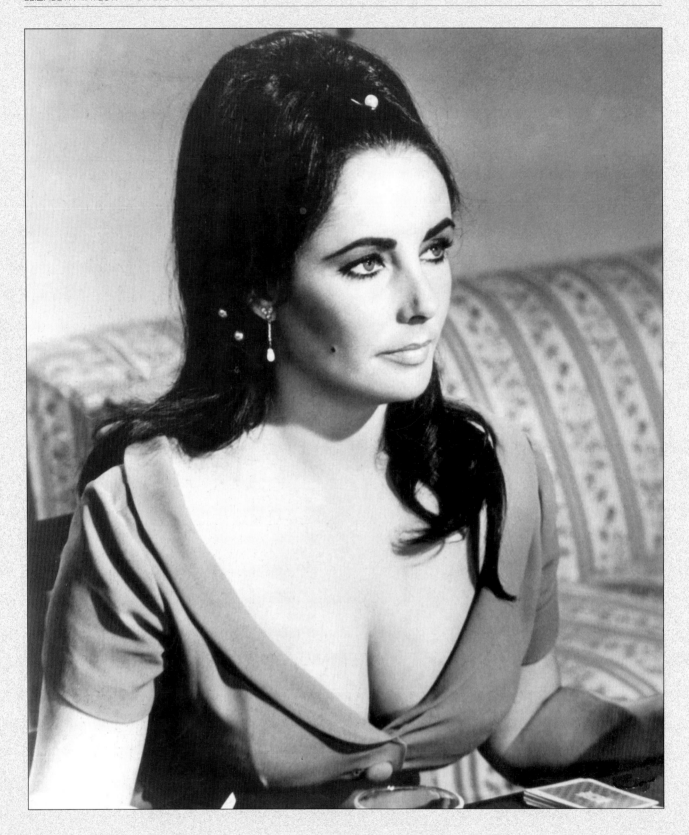

Elizabeth in a still from the film *Reflections in a Golden Eye*, 1967.

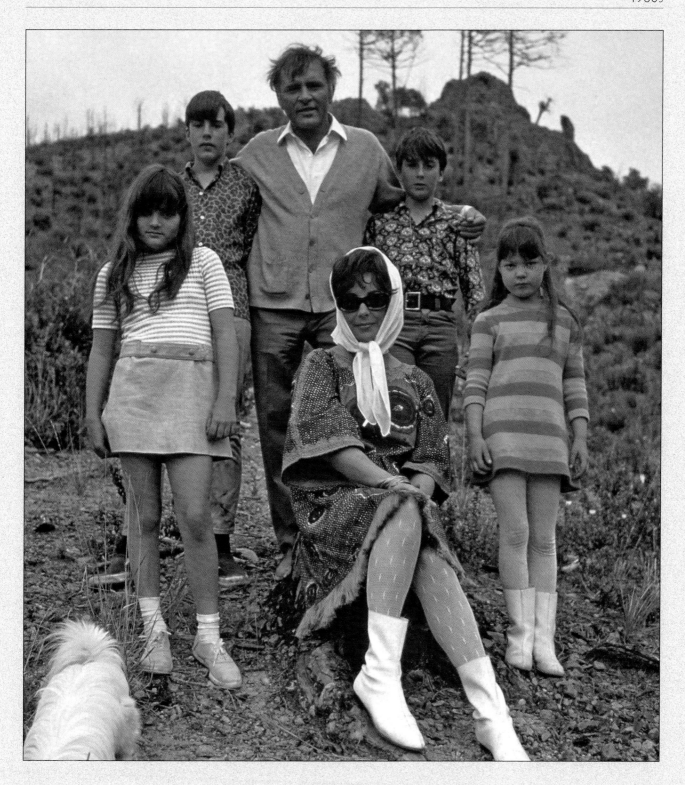

The Burton-Taylor clan; Richard and Elizabeth with their children –
Michael Wilding Jr, Christopher Wilding, Elizabeth Todd and Maria
Burton – in 1967. Taylor poses in an ethnic-printed, kaftan-sleeved
dress, with white headscarf, white lace tights and white leather
boots. Burton and the children are rather more soberly dressed.

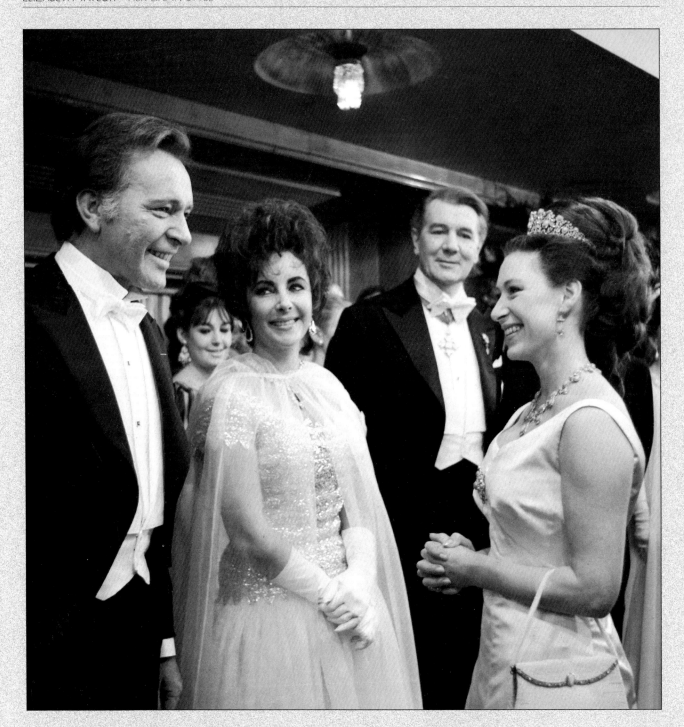

Elizabeth and Richard chatting to Princess Margaret, with Sir Michael
Redgrave behind them, at the 1967 Royal Film Performance of *The
Taming of the Shrew* at the Odeon in Leicester Square, London.

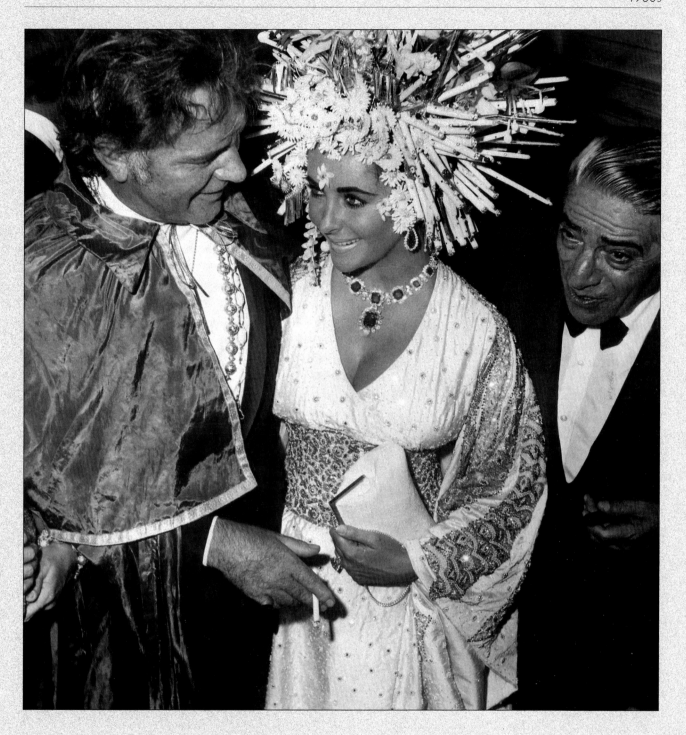

Taylor and Burton attending a Fantastica Ball at the Ca' Rezzonico,
in Venice, with Greek shipping magnate Aristotle Onassis on
September 20, 1967. Elizabeth's elaborate hairstyle was created for
her by French stylist Alexandre.

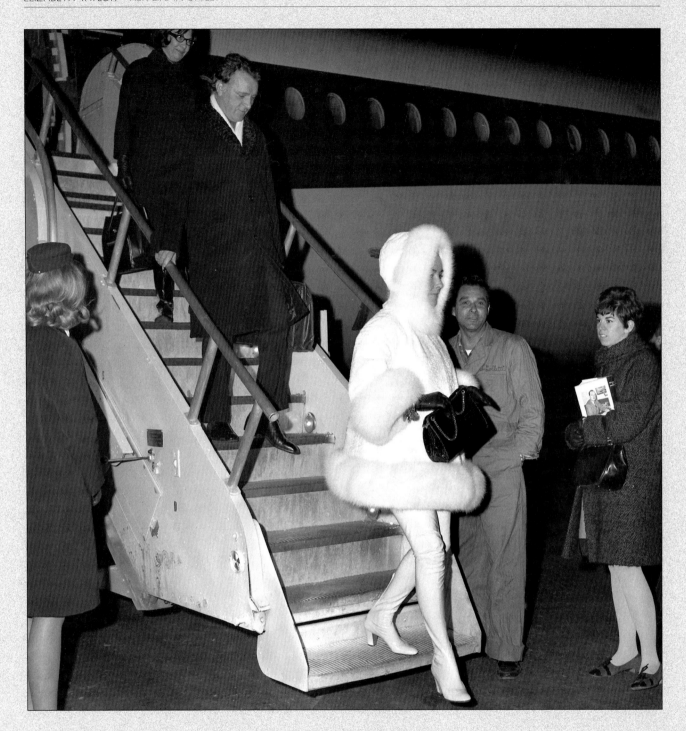

Kitted out in white leather hip-high boots with a white three-quarter-length ermine coat and matching hood, Elizabeth Taylor arrives at Kennedy Airport from London with husband Richard Burton in 1968.

RIGHT At the Paris premiere of *A Flea in her Ear*, in 1968. Taylor wears a feathery headdress and collar with her lemon-yellow embroidered dress, as well as her Bulgari emerald-and-diamond necklace and earrings.

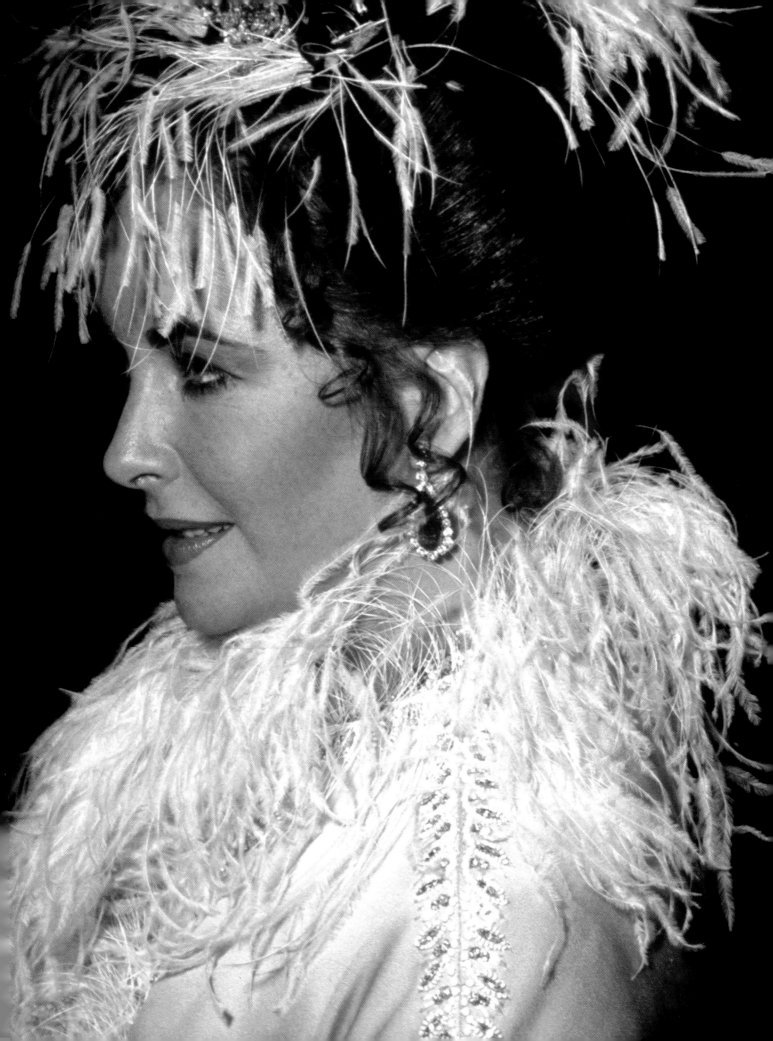

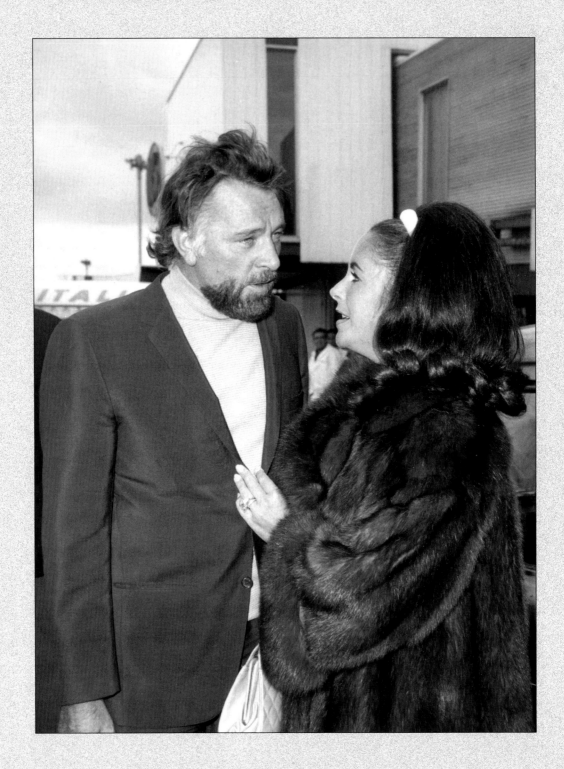

Elizabeth and Richard in May 1969 at Heathrow Airport in London.

1970s

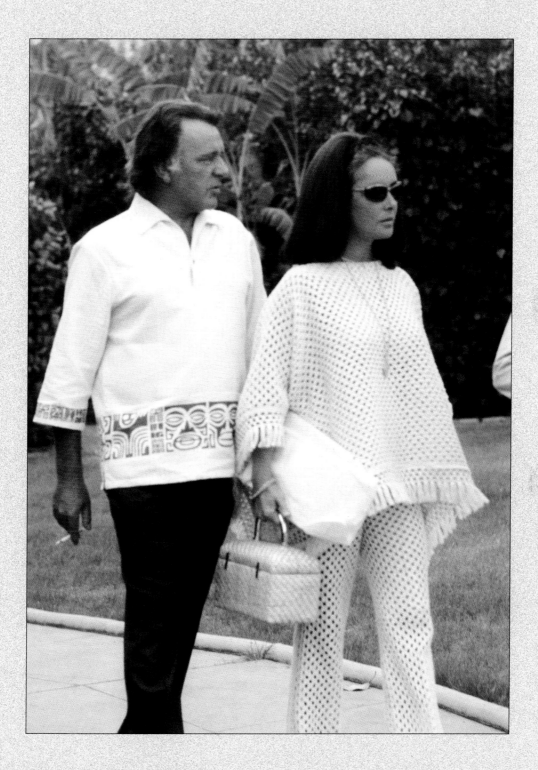

Elizabeth and Richard in Le Havre, 1970. Taylor is pure relaxed
1970s glamour, with her matching crocheted cream trouser-and-
poncho set, gold carry-case and sleek, teased-up hair-do.

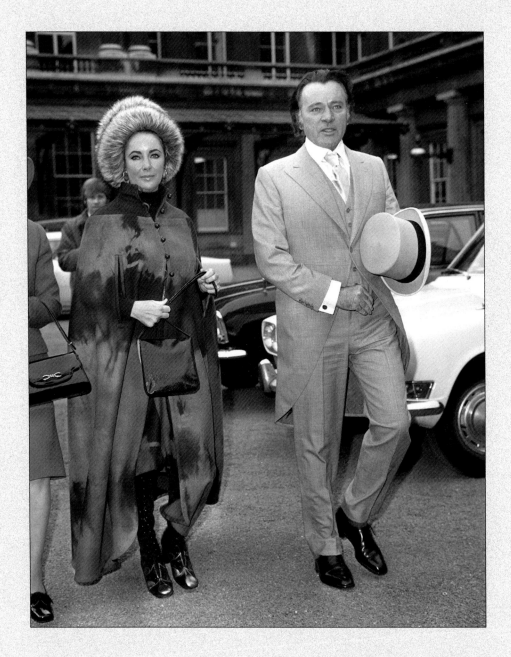

Richard Burton at Buckingham Palace with Elizabeth Taylor after he received the CBE from the Queen on his 45th birthday.

RIGHT Elizabeth Taylor, wearing an intricately-beaded, long-sleeved maxidress in 1970.

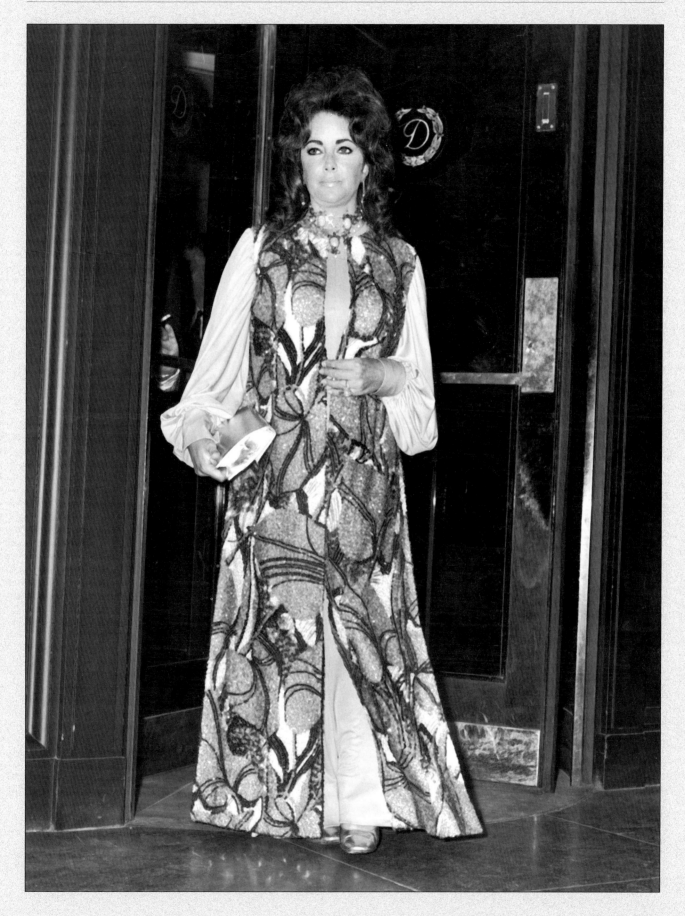

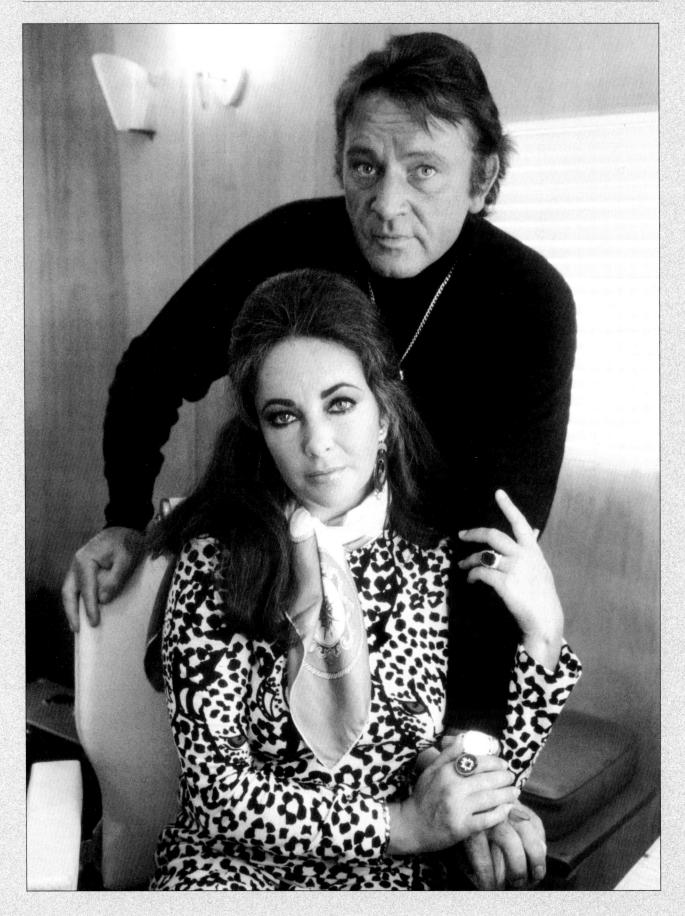

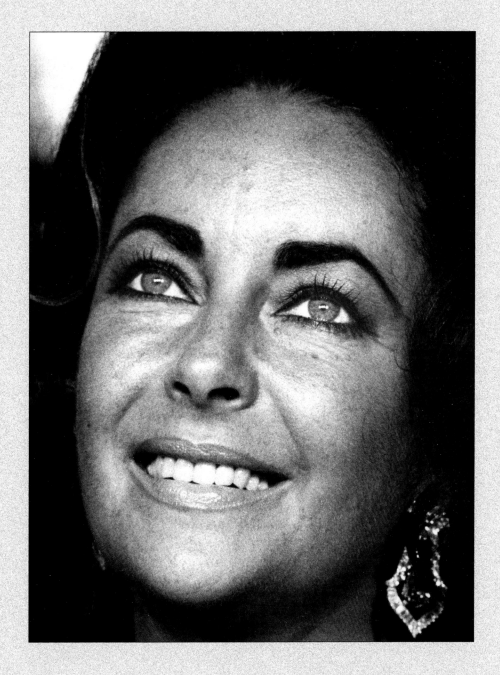

Taylor during the 46th Annual Academy Awards ceremony in New York City, 1974.

LEFT Elizabeth and Richard in 1971, in his trailer in Hounslow, London, on location filming *Villian*. Elizabeth wears an animal-print trouser suit with a simple silk scarf.

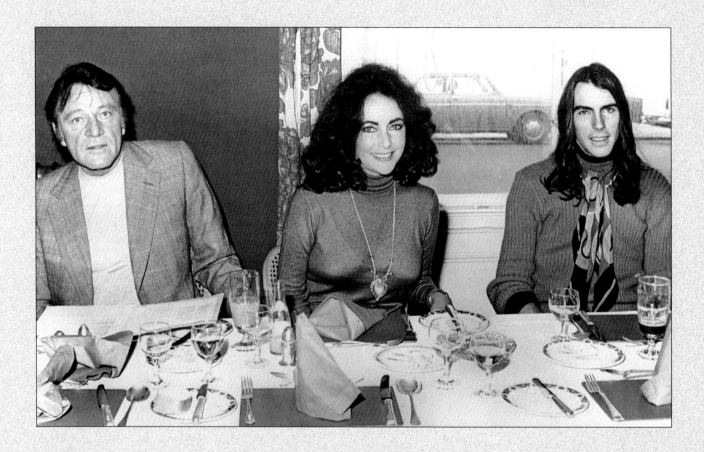

Elizabeth Taylor with Richard Burton and her son, Michael Wilding Jr,
in 1975. She is wearing a simple black roll-neck top, with the historic
Taj Mahal diamond necklace that Burton famously presented her
with for her fortieth birthday.

RIGHT Following her second and final divorce from Richard Burton,
Elizabeth married John Warner. This photograph shows the couple
together on the set of *A Little Night Music*, in 1976, before their
marriage. Elizabeth is wearing the elaborately-set Le Peregrina Pearl,
a gift from Richard Burton.

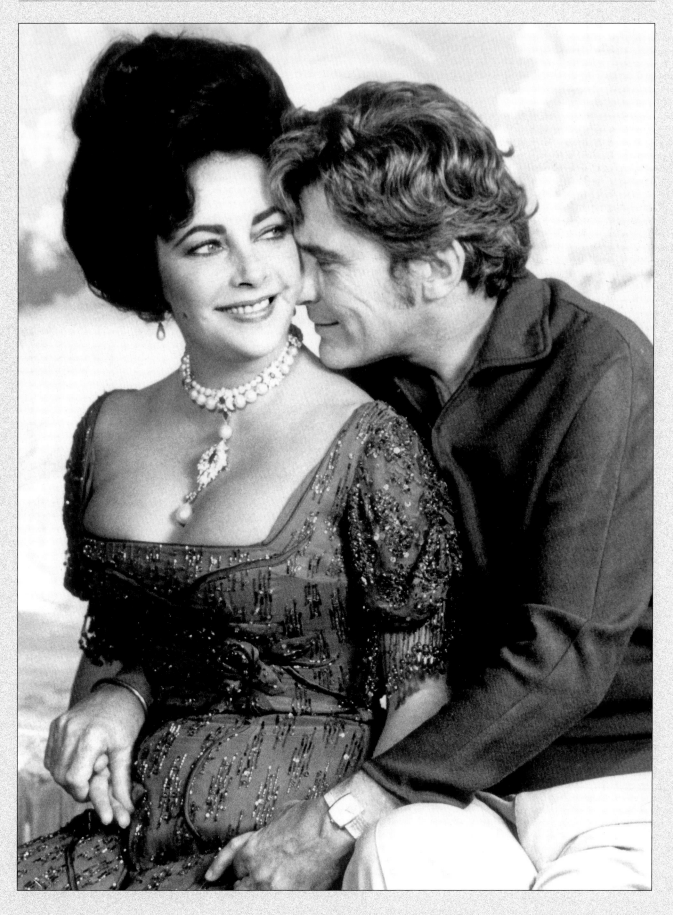

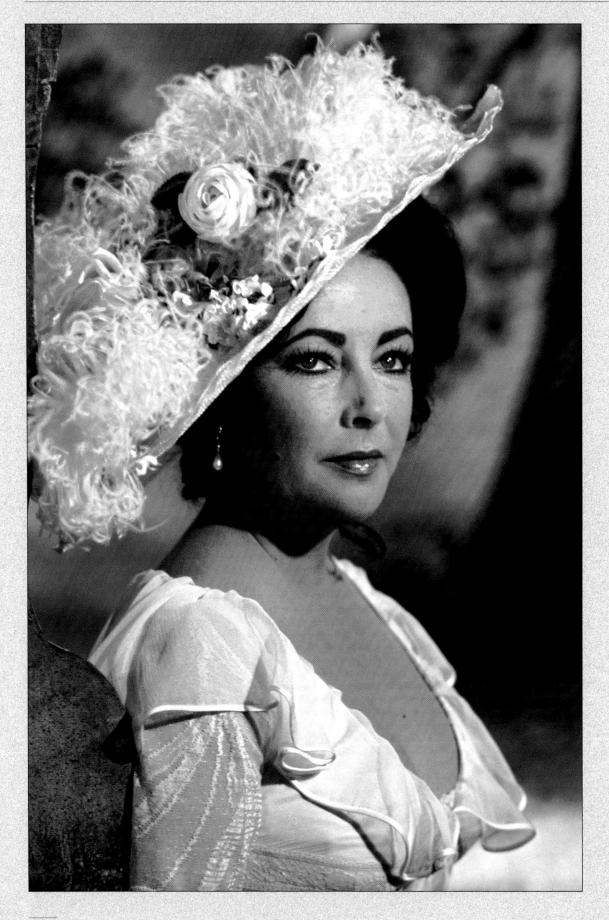

1980s

LEFT In period costume, on the set of
A Little Night Music, 1976.

RIGHT Incecked embroidered lace blouse,
with a suede jacket, 1982.

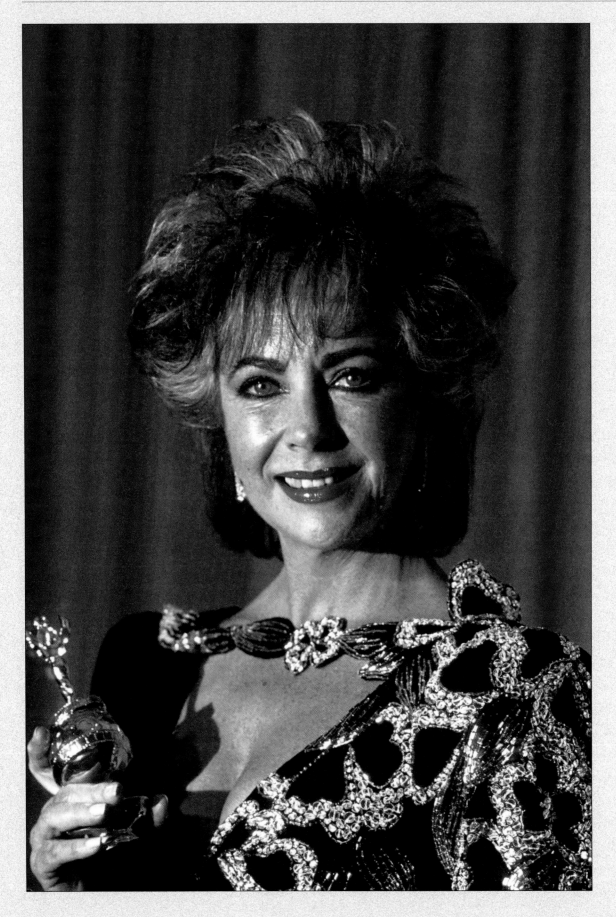

LEFT 42nd Annual Golden Globe Awards: Elizabeth Taylor in 1985.

RIGHT Elizabeth Taylor attends an AIDS benefit fundraiser in Los Angeles, 25th July 1986, her hair decorated with gems, feathers and ribbons. The chiffon overlay of her white dress is painstakingly embroidered and beaded to create an extraordinarily lavish effect.

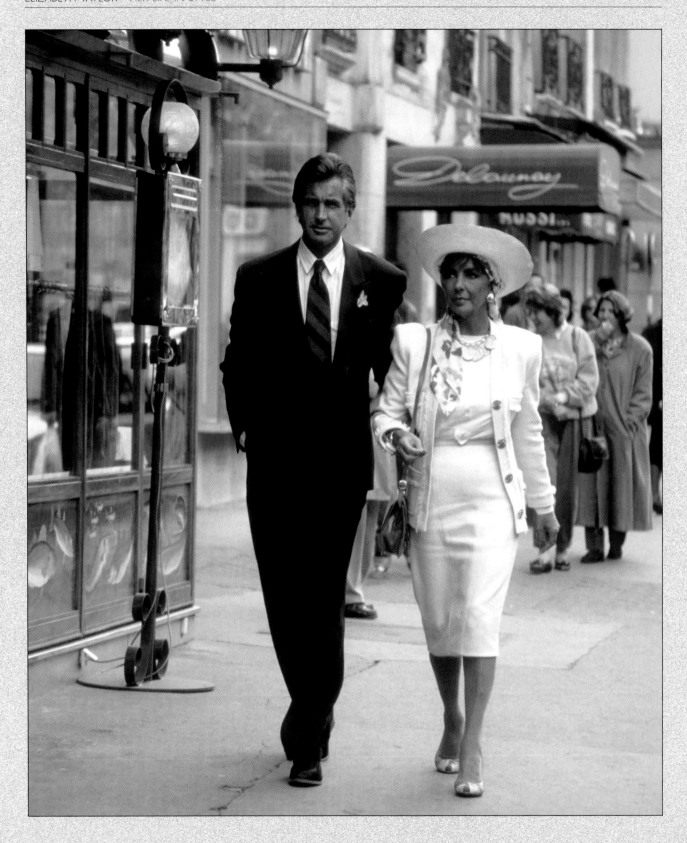

With George Hamilton in Paris, 1987. Elizabeth wears a chic,
neutral suit with an upturned-brim hat and cream peeptoe shoes
as they stroll down the street.

In 1987, Elizabeth Taylor's *Passion* was launched, the first fragrance in what would become an enormously successful range designed and developed by Taylor herself. She wore an unusual shiny and voluminous purple dress for the occasion. Her business empire would pave the way for the hundreds of celebrity-endorsed fragrances on the market today. Supported by a $10 million marketing campaign, the perfume promotion capitalized on Taylor's legendary beauty and glamour. Taylor was quoted as saying, 'Passion is the ingredient in me that has made me who I am. It's my passion for life… that has made me never give up.' Her success with *Passion* and *Passion for Men* led to another fragrance, *White Diamonds*, which was promoted with an advertisement showing Taylor watching a game of poker, then casually dropping one of her diamond earrings onto the table, saying, 'These have always brought me luck.' *White Diamonds* continues to be one of the best-selling celebrity fragrances, grossing a remarkable $61.3 million globally in 2010.

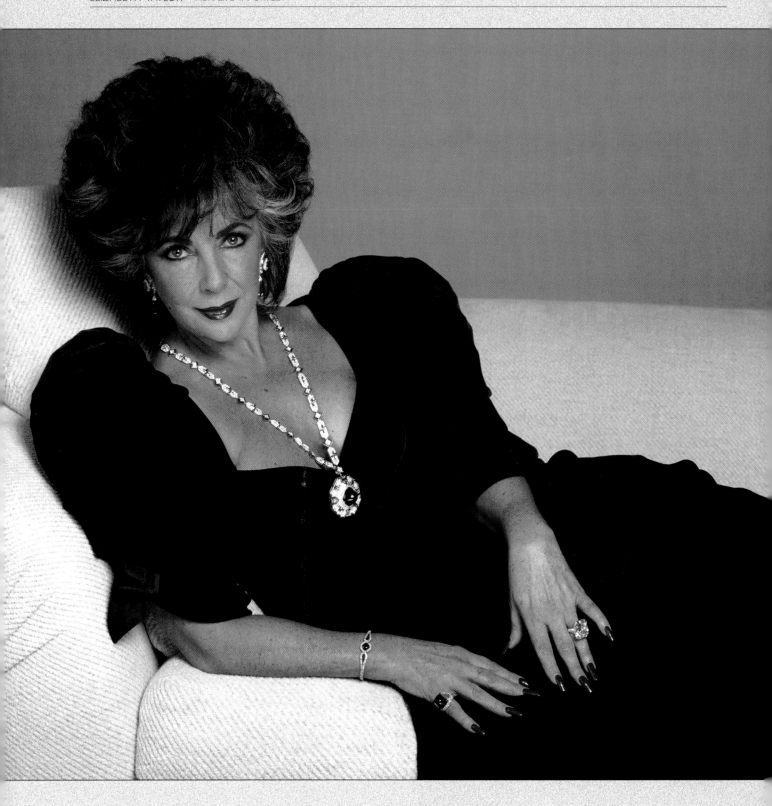

Elizabeth in a midnight blue velvet evening gown, wearing the
famous 33.19-carat Krupp diamond as a ring. She also wears the
Bulgari diamond and sapphire sautoir necklace she was given by
Richard Burton in 1969. It features a 321-carat Burmese sapphire
pendant.

1990s – 2011

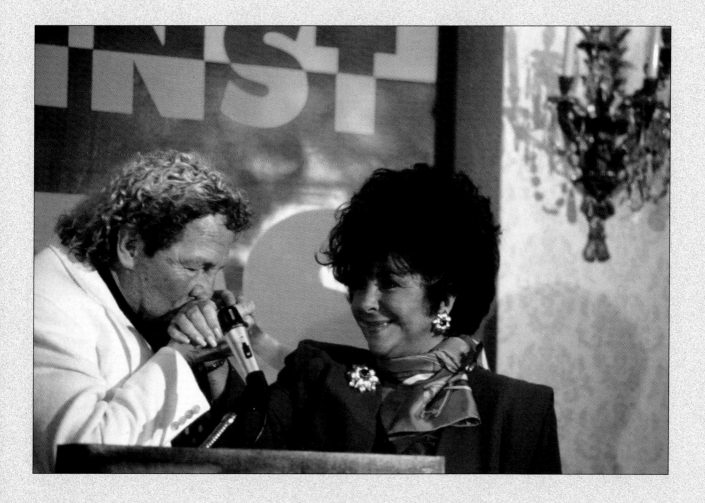

Painter Robert Rauschenberg kisses the hand of activist Elizabeth
Taylor at a press conference in Washington, DC, on March 5, 1990.
Taylor and Rauschenberg, representing 'Art Against AIDS,' held the
conference to publicize the need for more AIDS research. (Photo
by Brad Markel/Liaison)

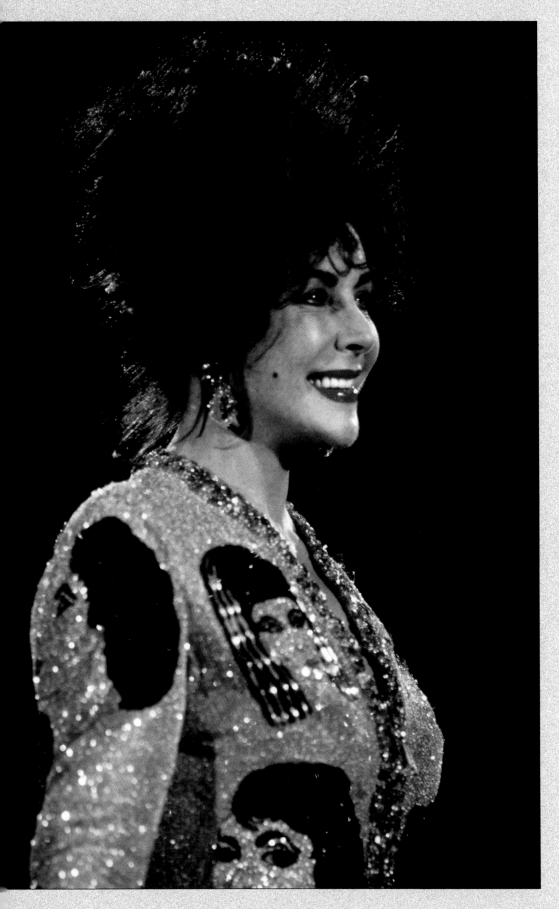

Wearing an iconic fully-sequinned
and beaded 'Cleopatra' jacket,
Elizabeth Taylor was honoured at
PACT at the Westin Bonaventure
Hotel on November 16, 1991 in
Los Angeles.

RIGHT Elizabeth wearing a pink dress
and AIDS awareness ribbon, in the
early 1990s.

In 1992, at the 64th Annual Academy Awards, Elizabeth Taylor
wears a simple white dress, her favourite shoulder-grazing diamond
chandelier earrings and an AIDS-awareness ribbon.

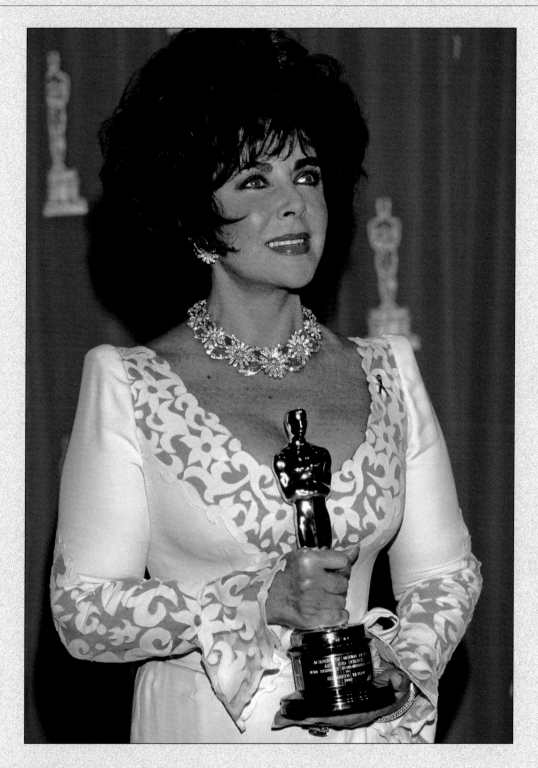

In 1993 Elizabeth Taylor was presented with the Jean Hersholt
Humanitarian Academy Award for her anti-AIDS humanitarian
work. For the occasion she wore a butter-coloured Valentino dress
and borrowed a white-and-yellow-diamond daisy necklace with
chrysoprase leaves by Van Cleef & Arpels. Following the ceremony,
she decided she couldn't part with the necklace and purchased it
instead of returning it.

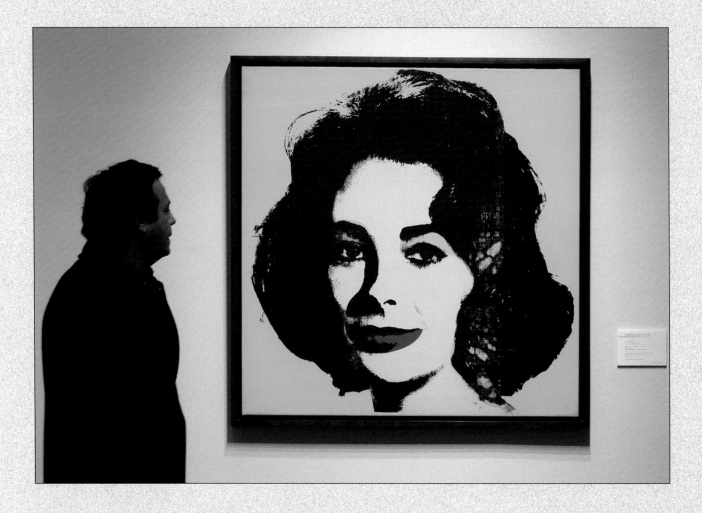

A visitor walks past 'Liz' by US artist Andy Warhol at Christie's
auction house before it went on sale for an estimated bid of
$25-35million USD in New York on November 12, 2007.

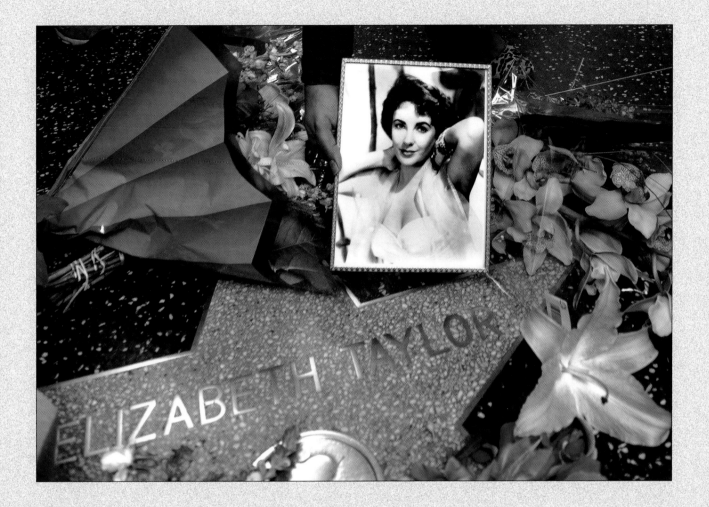

Legendary Hollywood actress and violet-eyed beauty Elizabeth
Taylor, who captured hearts in 'National Velvet' to launch a film
career that spanned five decades, died on March 23, 2011, aged
79. Taylor had been in Los Angeles' Cedars-Sinai hospital for six
weeks with congestive heart failure, a condition with which she had
struggled for some years. She was surrounded by her children –
Michael Wilding, Christopher Wilding, Liza Todd, and Maria Burton
– and is survived by 10 grandchildren and four great-grandchildren.

APPENDIX

Elizabeth Taylor's appearances:

1942 *There's One Born Every Minute*

1943 *Lassie Come Home*

1944 *Jane Eyre*
 The White Cliffs of Dover
 National Velvet

1946 *Courage of Lassie*

1947 *Life with Father*
 Cynthia

1948 *A Date with Judy*
 Julia Misbehaves

1949 *Little Women*
 Conspirator

1950 *The Big Hangover*
 Father of the Bride

1951 *Father's Little Dividend*
 A Place in the Sun
 Quo Vadis

1952 *Love Is Better Than Ever*
 Ivanhoe

1953 *The Girl Who Had Everything*

1954 *Rhapsody*
 Elephant Walk
 Beau Brummell
 Lady
 The Last Time I Saw Paris

1956 *Giant*

1957 *Raintree County*

1958 *Cat on a Hot Tin Roof*

1959 *Suddenly Last Summer*

1960 *Scent of Mystery*
 Butterfield 8

1963 *Cleopatra*
 The V.I.P.s

1965 *The Sandpiper*

1966 *Who's Afraid of Virginia Woolf?*

1967 *The Taming of the Shrew*
 Doctor Faustus
 The Comedians

1968 *Boom!*
 Secret Ceremony

1969 *Anne of the Thousand Days*

1970 *The Only Game in Town*

1972 *X,Y, and Zee*
 Under Milk Wood
 Hammersmith Is Out

1973 *Divorce His - Divorce Hers*
 Night Watch
 Ash Wednesday

1976 *The Blue Bird*

1977 *A Little Night Music*

1978 *Return Engagement*

1979 *Winter Kills*

1980 *The Mirror Crack'd*

1981 *General Hospital*

1983 *Between Friends*

1985 *Malice in Wonderland*
 North and South

1986 *There Must Be a Pony*

1987 *Poker Alice*

1988 *Young Toscanini*

1989 *Sweet Bird of Youth*

1994 *The Flintstones*

2001 *These Old Broads*

PHOTO CREDITS